THE
LEPINE
GIRLS
OF MUD CITY

dear Marcel & Andrea ~
So nice to meet you!
Happy reading.
Best wishes,
Evelyn Shade Gear
6/9/2012

THE
LEPINE
GIRLS
OF MUD CITY

Embracing Vermont

Evelyn Grace Geer

Charleston London

THE
History
PRESS

Published by The History Press
Charleston, SC 29403
www.historypress.net

First published 2012

Manufactured in the United States

ISBN 978.1.60949.431.5

Library of Congress CIP data applied for.

*To venerate the land
is to keep it alive,
no matter the struggle,
for it's a labor of love.*

*To venerate the land
is to make it lasting,
and in doing so,
honoring the human spirit and
the blessed spirit of all of nature;
its intrinsic balance and beauty,
forever benevolent to its keepers.*

—Evelyn Grace Geer

CONTENTS

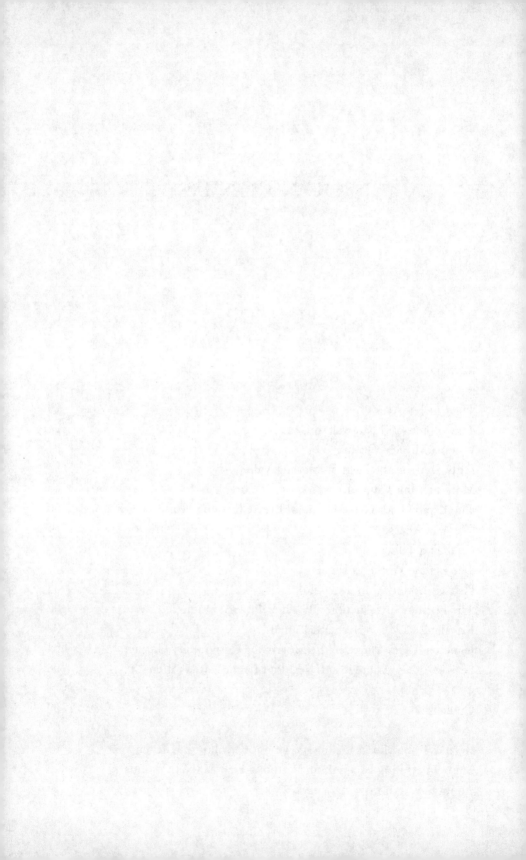

ACKNOWLEDGEMENTS

The story belongs to the people.
—Pearl S. Buck (born 6/26/1892 in Hillsboro, Virginia;
died 3/6/1973 in Danby, Vermont)

I dedicate *The Lepine Girls of Mud City* to the Lepine (pronounced le-peen) farm family of Mud City, located in Lamoille County in the northern part of Vermont, in the foothills of the Northeast Kingdom—*especially* to Mama, Jeanette, Gert, Therese and Marie, also known as "the Girls," as well as Papa, Andre and Lawrence Lepine. I appreciate the moral support and true-to-life stories, as well as what they have accomplished in and for the state of Vermont and its people. The Lepine girls are philanthropists in the state and supporters of Vermont Council of the Arts, one of many organizations they have supported over the years. Writing this book was a fascinating experience, as the Girls helped liberate yet another woman through their hard work and inspiration. C'est moi!

Known also as "the Girls with the Famous Hands," "the Doyennes of Vermont Dairy Farming" and "the Vermont Dairy Queens," over the years the Girls have triumphed over the daily struggles life can bring to single independent women, choosing their own rewarding careers and their lives on the farm. They danced to the beat of their own drummers. Mama Lepine set the paradigm for her daughters.

Gert said, "Mama kept us alive."

They have shared their enthusiasm, leaving a lasting impression in Vermont and doing so with reverence for and conservation of its beautiful and fertile hills and valleys.

ACKNOWLEDGEMENTS

Love to David Jonathan Earl, who left me and Sean, in Versailles, France, on October 2, 1994, for a celestial journey we could not share. When I wish upon a star, it is David.

Thank you to my commissioning editor, Whitney M. Tarella, and my project editor, Ryan Finn, as well as all those at The History Press who helped in making this book possible. Love to my true friend, Paul Hinton. For Tommy Fletcher of Kilroy Construction and his companion, Barbara Neal, two very special people in my life. Much love and thanks to my husband, Jake Geer, for his wonderful suggestions. His turns of phrase are colorful and quite creative. Thank you to Glenn Callahan, whose beautiful photograph graces the book cover.

Thanks go to masseuses Erin Grimes and Cheryl Small and spa assistant Nori Towns at the Golden Eagle Spa and Resort; Kathy Kiernan, the assistant general manager, for her kindness and encouragement when I needed a quiet place to write this book; and Herb Hillman and his family, who originally made the Golden Eagle Resort a lovely place to restore one's spirit in 1961—Herb's flower gardens, eye for detail, understanding of people's need for a private place for respite and his j'oie de vivre are an inspiration to the many people who love him.

Thanks to Heidi and Chris Townsend of the Black Cap Coffee Roasters, which used to house Stebbins's Meat Market, Stowe's oldest store. Their coffeehouse is where I wrote a good part of this book, as I enjoyed their special brews and kind hospitality.

Thank you to the Stowe Free Library and its staff members, Rebecca, Marcia, Molly, Julie, Angela and Megan, who seem to be the foundation of the library and are always reliable, helpful and cheerful and always there when one needs some bookish information. Vermont just wouldn't be Vermont if we didn't have our libraries.

Thank you to Dr. David Bisbee, the founder of Stowe Family Practice. He is one of the solid foundations of the Stowe community. He also volunteers his medical knowledge and care through the organization Doctors Without Borders and spends part of his life caring for the poor and underprivileged in Honduras.

Finally, in memory of my parents, George and Catherine Streeter. Through them, I received a heritage from their Irish and Italian immigrants who came to America of which I am proud.

For Sean Patrick Earl, my son and my wild Irishman, with all my love.

And thank you God for all of the above.

INTRODUCTION

This is a story that could only have happened in Vermont. It is a story of the Lepine family's emigration to America from Canada and the life they built in Vermont.

The Lepine Girls of Mud City told me their story, and I present it to you, my readers. If not for their lives in Vermont, the Girls would not be the same women, nor would the events of their lives have played out so wondrously. Some of you may never have tasted the beauty of the Green Mountain State. I shall whet your appetites.

Gert and Jeanette, two of the Girls, are art enthusiasts, sportswomen, gardeners, voracious readers, campers, farmers and fishermen, as well as quite bright, popular and well respected in the Green Mountain State. If you can claim them as your friends, you are all the more blessed.

Gert is eighty-five and Jeanette, eighty-three. Their sister, Marie, who left the farm early on, is eighty-eight and has come back to live with Jeanette and Gert after an exciting life quite different from theirs. Mama and their dear Therese have passed away.

Jeanette and Gert, a real team for many years, are informed on world events and what goes on in the state through experience of sunrises and sunsets through the years and all that falls between. They are so well known and liked that the Catholic church they attend in Morrisville changed the hours of its Saturday afternoon Mass to coincide with the Girls' milking schedule. They love going to Mass on Saturday afternoon. It's written into their weekly routine and has been for years. And they are women who grew up on routine.

Gert said, "When we were kids, Mama had a day of the week for everything. Back then, Sunday we went to Mass. Monday was wash day, I remember. And once a week, I think it was Saturday, us kids would wash all the windows in the house until they sparkled. Oh yes, she had a weekly schedule. I guess with six kids and a husband, she sort of had to."

Mount Sterling Farm in Mud City—Gert's farm, where the whole family had once lived and is now where the Girls reside—is an eclectic art gallery as well as a cozy home with a woman's touch. An antique hutch sits in the corner of their dining room decorated with Hummels, family photographs, cards and letters. In summer, there is always a bouquet of fresh wildflowers as a centerpiece on the dining room table.

There's a life-size antique horse in the living room, acquired during Jeanette's days when she ran her Mud City Antique Market, held at her farm. It's not the same farm where she lives with Gert. She calls her farm Clyde's, and I will explain that later in the story.

At Mount Sterling Farm, paintings by Vermont artists hang on the walls, mixed among paintings from as far away as Russia. A favorite of mine is a rooster painted in oil by Jane Desjardin, a former neighbor who just sold her place to travel.

` Vermont is different. It has the highest of the following per capita in the nation: libraries, Peace Corps volunteers, farmers' markets, organic certified farmland, amount of money spent on local food, breweries (one for every thirty thousand people), artisan cheeses, percent of unpaved roads, dairies, tennis courts and wildlife watchers (60 percent of Vermonters are wildlife watchers of some species or another). A high percentage of Vermonters are birdwatchers—songbirds and birds of prey—and every year many Vermonters go out to Dead Creek in Addison to experience the incredible sight of thousands of snow geese resting between flights as they make their way north and south on annual migratory routes.

Jeanette and Gert kayak in spring at Zach's pond in the outskirts of Morrisville in a hamlet called Garfield, where they paddle their sleek red vessels between the lovely loons that swim elegantly through the water at a quickened pace. The Girls enjoy watching the mama and daddy loons teach their young to swim and fly, and then away they go in the autumn. Loons mate for life, and though they separate in the fall (maybe there's more to this than meets the eye), they return to each other in the spring at the same mating place as before.

Jeanette said, "Sometimes, when the babies are flying away, the parents' cries are so mournful. It's really touching. It's like they have the emotions of humans."

Their love of birds is reflected at the birdfeeders they have at Mount Sterling Farm. Birdfeeders are part of the backyard scene in Vermont at most private residences, where charms of bright yellow goldfinches and perky little chickadees, dressed to beat the band in their tuxedo-like patterned feathers, come to eat and socialize, respectfully taking turns at the sunflower seed feast. This spring, the Girls counted twenty-eight goldfinches at their bird feeder that sits outside of their dining room window at Mount Sterling Farm. The Girls have bluebirds at the farm in the summer, as well, dressed in as elegant a shade of blue as God has ever made, if I may say. They brighten the meadows as they fly, finding berries galore on which to feast.

Maybe it's a combination of the long, snowy winters and folks blessed with good old-fashioned Yankee ingenuity, living out in the country with independent attitudes and a lot of smarts. Whatever it is, Vermonters love to create things, both practical and esoteric. Mama Lepine and Jeanette created elegantly designed caned chairs, enabling them to restore old classics. The art of chair caning, or seat weaving, is a craft that takes great concentration and skill, and the results are gracefully beautiful. Imelda was perfectly fit for the work, and Jeanette can still cane chairs but hasn't done much of that since Mama died. Mama hooked colorful rugs, too, and created beautiful clothing in wonderful fabric remnants for her six children. You'll read in the book about the children's creations when they were growing up in Vermont.

Gert said, "If we wanted something, we'd figure out how to make it."

In this story you'll read about Emily, a ghost who haunts the Gold Brook Bridge up in Stowe Hollow in the neighborhood where Gert taught school in a one-room schoolhouse—at least until a day in spring when she quit teaching altogether to start her award-winning herd of Jersey cows. She recalled, "The sap was running and so was I!"

You'll see how the Lepines were athletic—hiking and skiing and working the farm. Therese and Jeanette enjoyed hiking Mount Mansfield together as adults.

"It was years ago, when I was at the farm. I was home for a visit, while working for Pan Am as a stewardess. Therese had taken a vacation from her job in Washington, D.C., and so she was home too. We started in Duxbury and hiked to the top of Camel's Hump and camped for the night," Jeanette said. "Then we hiked our way down. We stayed in a different place every night. We hiked some great trails! There was Bolton, Taylor, Butler, Taft and then Mount Sterling. It is so incredibly beautiful at the summit. At the top of Mount Sterling, or Whiteface as it's also called, there is a beautiful pond and it was covered in waterlilies!"

Mount Mansfield is the tallest mountain in the state, its peak reaching a height of 4,395 feet above sea level. The mountain is named for the dissolved town of Mansfield, where it was located until Mansfield became part of Stowe. Stowe was named for a town in England in the Cotswolds and was originally spelled "Stow." This is interesting in the sense that there has never been an English colony established in Vermont.

The toll road on Mount Mansfield was built in 1856 and was originally used by saddle horses. Now the road takes sightseers to the top of the mountain to view the amazing vistas during the glorious summers and peak foliage seasons. The mountain's summit is located in Underhill on the other side of Smuggler's Notch from Stowe. Its ridgeline extends into the town of Stowe, and Cambridge holds some of it as well. More than two hundred acres of Alpine tundra grows on the summit, as it has since the ice age. The Long Trail is cut through the mountain's ridge and is a stimulating hike.

It's been said that anyone who can ski all the ski trails at Stowe Mountain Resort can ski any other trail in the world. Jeanette Lepine skied Mount Mansfield with her sister Gert back in the 1940s, when the lone rope-tow lift was powered by a 1927 Cadillac engine at the Toll House. A ride up cost a whopping ten cents. A season's pass was five dollars.

The Girls originally taught themselves to ski on Sterling Mountain. Later in her life, Jeanette traveled to the Austrian Alps, another adventure during her world-traveling airline stewardess days. She said, "I took a bad fall and injured my knee. I just had it replaced." So there you go!

Gert said, "Who came up with that old adage anyway about if you can ski Mount Mansfield you can ski anywhere?" This question made Jeanette chuckle. Those two love to laugh.

Mount Mansfield has a supine image of a man's face—forehead, nose, chin and Adam's apple. Gert said, "In the nineteenth century, Ralph Waldo Emerson hiked the Nose, experiencing the beauty of a sunrise as he gazed out at the remote peaks of the White Mountains in New Hampshire, rising high, off in the far distance."

He was rusticating while writing—one of his many transcendental and existential experiences. Emerson wrote, "To go into solitude, a man needs to retire as much from his chambers as from society…if a man would be alone, let him look to the stars. The rays that come from those heavenly worlds will separate him and what he touches." I can't help but think that as he sat, possibly in a yoga pose on the summit of Mansfield, his soul rose to that esoteric state of mind, and he communed with other realms of creation expressed in his creative voice.

Emerson was well received in Vermont, not only by the landscape but also by its people. Julia Carolyn Ripley Dorr, founder of the Rutland Library, graciously invited Emerson to her home there. She was born in Charleston, South Carolina, to an international banker. She grew up in New York City and Vermont, graduating from Middlebury College. She is considered one of *the* literary personalities of the nineteenth century and enjoyed writing about the lives of New England women most of all. Her characters rise from poverty through self-determination, education and perseverance; as you shall see as you read the story here, the Lepine Girls of Mud City did, too.

Dorr is best known for her novel *Sybil Huntington* and for her poetry. The Rutland Free Library houses an extensive collection of her work in its Vermont Room. She was born in 1825, passing away in 1913. Her remains lay at rest at the Evergreen Cemetery in Rutland, Vermont, where she's buried among relatives, some of whom went down in a shipwreck at sea. If she had been here now, I would have to vie for the writing of this piece, I imagine.

The thirtieth United States president, Calvin Coolidge, was born on the Fourth of July in 1872, in Plymouth, Vermont, at his family's homestead there. His father answered the door in the middle of the night to receive a telegram noting that President Harding had died suddenly in San Francisco. Calvin Coolidge's father administered the presidential oath to his son at their Vermont home.

Later on, President Coolidge traveled from Washington, D.C., by train to his native state after the disastrous flood here in 1927. With intense emotion, uncharacteristic of his "Cool Cal" personality, he gave a speech at Bennington College on September 21, 1928, praising his home state and its inhabitants:

> *My fellow Vermonters: For two days we have been traveling through this state. We have been up the east side, across and down the west side. We have seen Brattleboro, Bellows Falls, Windsor, White River Junction and Bethel. We have looked toward Montpelier. We have visited Burlington and Middlebury. Returning we have seen Rutland.*
>
> *I have had an opportunity of visiting again the scenes of my childhood. I want to express to you and through the press to the other cities of Vermont, my sincere appreciation for the general hospitality bestowed upon me and my associates on the occasion of this journey.*
>
> *It is gratifying to note the splendid recovery from the great catastrophe which overtook the state nearly a year ago. Transportation has been restored.*

The railroads are in better condition than before. The highways are open to traffic for those who wish to travel by automobile.

Vermont is a state I love. I could not look upon the peaks of Ascutney, Killington, Mansfield and Equinox without being moved in a way that no other scene could move me. It was here that I first saw the light of day; here I received my bride, here my dead lie pillowed on the loving breast of her eternal hills.

I love Vermont because of her hills and valleys, her scenery and invigorating climate, but most of all because of her indomitable people. They are a race of pioneers who have almost beggared themselves to serve others. If the spirit of liberty should vanish in other parts of the Union, and support of our institutions should languish, it could all be replenished from the generous store held by the people of this brave little state of Vermont.

"Moonlight in Vermont," a lyrical song in haiku stanzas by John Blackburn and Karl Suessdorf and published in 1946, praises Vermont's charms, as well. The song also describes the way of life that the state inspires, where locals wear many "professional hats," often "moonlighting" to be able to stake claims on Vermont as their home—creating with their hands, landscaping the land for gardens and pastures for livestock and backyards for chickens and children. Some Vermonters raise grass-fed steer on their land, injecting no hormones or antibiotics into the animals, choosing instead to grow organic livestock. Charcoal-broiled hamburger from this ground beef is out of this world and incomparable to any other. You can taste the sun, fresh air and sweet grass. The grocery stores can't seem to keep it in stock. It seems to fly off the shelves.

Gert said recently when we were going over this book, "The first three lines of the song 'Moonlight in Vermont' are, 'Pennies in a stream / falling leaves of Syacamore / moonlight in Vermont.'"

Both Jeanette and Gert have never seen a sycamore tree in Vermont. There are actually a few here and there. I've heard there is one in Harmonyville, Vermont. There's one in Townsend. There's one in Shelburne. I've seen a big beautiful one in Middlebury.

Jeanette said, "I'm surprised they didn't include maple trees in that song. That is the state tree." Jeanette should know all about maple trees. Her Mud City Maple Syrup just won an award for the Best Maple Syrup in the World. She gave me a quart of it to take home, which was very generous, considering the bad year they had in the state for sugaring. It was a strange spring. We had ninety-degree weather in March. Some blame it on global

warming. The maple trees got confused, I guess, and held back. It dried up their sap run. Anyway, Jeanette's maple syrup is indescribably delicious. It has a unique, piquant flavor unlike any other maple syrup I have tasted. I like to put it in my tea with a wedge of organic lemon.

There are sayings here: "Vermont's a small town" and "Vermonters are a little *different*." Okay, so we may be a bit eccentric. Vermonter Timothy Clark Smith's 1893 crypt includes a window in case he was buried alive. Vive la différence!

Vermont's state motto is "Freedom and Unity." I devote this story to the past on into the future of the Green Mountain State I so dearly love and to all who have, do or ever will "Moonlight in Vermont," especially the Lepine Girls, who have done their share of moonlighting, especially in the spring during sugaring season. When the sap runs, you cook your syrup!

You may wonder how this book came about. I'll tell you. Gert and Jeanette were nearing their seventies when they brought firewood by pickup to me and my son Sean's home in Sterling Valley, a short meander up the road from where the two shared some of their happiest childhood memories, along with their brothers and sisters, Andre, Lawrence, Marie and Therese, and their parents, Mama and Papa Lepine. Their place is "just down the road a piece" from our place at their old family homestead, 150 acres of pure Vermont.

The day they came to deliver the wood for Sean and me to stack, Waldo, their boisterous beagle, was sitting snugly between them in the front seat of their pickup truck, overloaded with a generous half cord of wood that Gert had just cut and split. I commented on the clean, neat cut of the wood.

Gert said to me with a smile, "I just love my chainsaw," pushing her fishing cap back off her forehead. As we handled the wood, we shot the breeze. On this pristine golden autumn day, I expressed to Gert my love of the written word, sharing a piece of writing I was working on, about a time Sean and I had spent in Paris and Versailles, France, in the autumn of 1994.

Gert said, "I like the way you write. I mean I like your style. How would you like to write the story of my family?" I ran for my pen and paper, and they began to tell me their tales.

Let me share with you a story about the Lepine farm family of Mud City, Vermont.

THE QUEBEC YEARS

Lovers of the fleur-de-lis, culture rich in history, architecture, folklore,
cuisine. C'est bon Quebecoise, notre petite Françoise.
—Evelyn Grace Geer

About 900,000 French Canadians from Quebec immigrated to the
United States during the late nineteenth century and early twentieth
century. It was a time of mass immigration, and these French Canadians
were part of a group of foreigners that came seeking good fortune and a
healthy way of life in the States. About 55,000 settled in Vermont, many in
Lamoille County, bringing their traditions and richly flavoring the culture of
the Green Mountain State.

From a small parish in Quebec (derived from the Abenaki name Kebec,
"where the river runs narrow"), Maurice Lepine and Imelda Paiement met
as budding young adults, creating a union and the seeds of a new generation
before immigrating to Lamoille County, Vermont. With their children, they
created a lifetime of farming and a lasting legacy there.

Maurice came into the world as the Lepine family's firstborn son. It was a
tradition in French Canadian families in Quebec that one of the sons become
a priest. The first two sons in a French Canadian home were educated at a
monastery, compliments of the Catholic Church, with the hopes of one of
them becoming a priest. So, from the beginning, Maurice's life was directed
toward religion, but only fate would tell the outcome.

It was a cold winter morning in the late 1800s. Church bells rang from
the bell tower of the small Gothic church in the village of Saint-Joseph-de-

Ham-Sud, Quebec. Snowflakes danced. Wild wind masked the cries of a pack of coyotes involved in a bloody chase in the surrounding hill country.

Over the years, eleven more children would be born into the Lepine family. Farms needed good strong workers, and the Catholic Church encouraged the "grande" size, offering a regular stipend to parents for every child raised a Catholic. The remuneration was awarded until the child was eighteen.

When Maurice was sent away to the monastery in a borough of Quebec City, he learned penmanship and developed a beautiful script. One's handwriting was a reflection of who one was, truly an art form of self-discipline.

Imelda Paiement was born on the Saint Lawrence River in the town of Rigaud in 1902. Her mother died of consumption when Imelda was three after washing clothes in a river on a cold, damp day. Five years later, Imelda's father died.

Taken in by the Sisters of Charity of Montreal, Quebec, and living at their orphanage, Imelda was educated and "mothered" by the sisters. The convent (couvent in French) and orphanage were founded in 1737 by Marguerite D'Youville, a Quebecoise and a wife and mother before becoming a nun. She gave birth to six sons, with four dying in childhood. Her husband passed away. He had traded liquor for fur with Ojibwa and Abenaki Indians of Quebec. Due to his infamous reputation, Marguerite's Sisters of Charity were known as the "Grey Nuns" or "Grises," a French colloquialism alluding to drunkenness. When the convent and orphanage prospered spiritually and corporeally, the designation Grey Nuns was a reminder to her of sorrows endured, lest she should soften and lose the focus of her life's journey. She held on to the name with determination.

Marguerite began the order in a house in Montreal, taking in the poor, the disabled and the orphaned. She envisioned God in all beings, dedicating her life to caring for others; she was beatified a saint in 1959 by Pope John XXII. The order of the Sisters of Charity soon branched out, purchasing a convent in a borough in Montreal, reaching out to battered women with and without children, the incarcerated and the orphaned. Although the sisters began their charity in Canada, they went as far as the United States, Colombia, Brazil, Japan, Haiti, the Central African Republic, South Africa, Papua New Guinea, Paraguay, Argentina, Uruguay, the Bahamas and the Dominican Republic on their mission.

When Imelda lived at the convent, church bells rang in the morning, announcing Mass, followed by le petit dejeuner (breakfast). Quebec's longest season is winter, when rosy-cheeked orphans in fur moccasins shuffled from

the convent's church across a cobblestone common to a dining hall. The girls were dressed in flannel skirts over jupens (heavy slips), long-sleeved blouses and woolen capuches (caps). Passing the kitchen, the children's appetites were teased by the steamy aroma of bubbling oatmeal and blackstrap molasses. Grace and breakfast prepared them for a day of studies, singing, dancing, chores, prayers and play.

Luminous orange coals crackled and hissed on the hearth that smoldered with a dry heat, as dancing flames created a slow roar like the ocean sounds from a seashell held to one's ear. Windowpanes glittered blue and gold in patterns of sunlit frost like French lace.

The children celebrated their folklore through singing and dancing "le gigue," square dancing to fiddles, harmonicas and clanging spoons. A favorite French folksong brought to Canada is "Alouette," concerning the fate of a lark. Birds were and still are eaten as game in Quebec, the pigeon and the lark being favorites. Through music and rhymes, "Alouette" weaves a tale about a plucking.

Maybe if only subliminally, French Canadians understood tradition as a sacred element of the human life experience, making better understood who they were, where they came from and what they would bring to life, wherever they went.

Imelda's Tante Eva and Uncle Luger's home was in the valley of Mount Ham, created by a volcanic mass standing 713 meters high, its crest boasting a 360-degree view. Pristine Lac Nicolet still holds good eating fish. In summer, Imelda returned to Ham-Sud, living with Tante Eva and Uncle Luger on their farm, happiest in a natural environment. The fertile earth was turned and plowed. Green shoots created fractals in the dark, moist soil. Summer wore lupines, pink meadow roses and purple irises. Cow manure was shoveled into the earth, and the wet smell of running springs made the air an invigorating tonic to the nose.

On Canadian farms, raw milk, rich and creamy, was a true country cocktail. Crème fraiche was served with berries and cereal. Sweet butter and honey collected at the apiary were spread on toasted home-baked bread.

When the snow geese migrated south, the chilly air was punctuated with honks and visions of the birds' whiteness floating in patterns like giant puffs of cotton and apples, grapes and red berries contrasted with the sky in a beautiful way, announcing the change of the season.

Imelda bid au revoir to Tante Eva and Uncle Luger, returned to the convent, graduated and then came back to the farm. She became an elementary school teacher in Ham-Sud. Attending Mass there, she met

Maurice Lepine. He was twenty-two years old and had recently completed seminary school.

Maurice had returned to the village and his farm. Maurice met Imelda and they fell in love. Imelda had always loved children, and the idea of having a farm with Maurice and raising a family made her heart light. She could finally have the family she had lost as a child. What would Tante Eva and Uncle Luger say? She knew that they would give her their blessing. Maurice and Imelda decided to get married. Gert Lepine said, "I doubt if Papa [Maurice] asked Mama [Imelda] to marry him. I bet it was more Mama making that decision." She smiled as she recalled her spirited Mama's strong will.

The wedding was held in Ham-Sud. Bells chimed, bringing in the morning on that cold, clear morning when blue skies met the heaven and a new life began. They bought Maurice's parents' farm in Ham-Sud. Imelda gave birth to Marie and then Therese, André, Gert and Jeanette. Laurence was born later, in a farmhouse in Hardwick, Vermont.

It was the beginning of the Great Depression, when the Roaring Twenties roared no more, beginning with the Crash of 1929. Canadian farm costs outweighed profits as the price of wheat decreased to less than the price of seed. Maurice and Imelda were among the majority of folks who "lost the farm." Gert said, years later, "Cows were selling for five bucks."

Singer Rudy Vallée of Island Pond, Vermont, famous for the song "As Time Goes By" of *Casablanca* fame, got it right when he also sang, "When there was earth to plow or guns to bear I was always right on the job. Once I built a railroad, made it run, made it race against time. Once I built a railroad. Now it's done. Brother, can you spare a dime?" The "Coolidge prosperity years" were just a fond memory as farm crop prices fell 60 percent throughout North America. Maurice wrote letters mailed with three-cent stamps to his brothers Irenee and Wilfred, Canadian immigrants to Lamoille County, Vermont.

Let's talk about Lamoille County. Where did the name come from? Samuel de Champlain intended to name the Lamoille River (the main river that flows through northern Vermont and flows north into Lake Champlain) La Muette (French for seagull). When the French explorer came upon what is now the Lamoille River, he spotted a flock of seagulls, some on the water and some above the river in flight. Quickly writing the name La Muette down on his sketched map, he failed to cross his t's. De Champlain handed his sketches over to his professional mapmaker. The mapmaker interpreted De Champlain's "La Muette" as "La Moille," thus officially entering it on the map, and the name was born for the river and the county.

Embracing Vermont

De Champlain is recorded as the first white man to set foot in what is now the state of Vermont. He traveled from Canada with Algonquin Indians in a battle against the Iroquois. He had earlier established New France, or Quebec. Samuel de Champlain named the largest lake shared by Quebec and Vermont, covering over half of Vermont's western border, Lake Champlain, changing it from the Abenaki name Petowbowk. There have been more than three hundred sightings of the Lake Champlain monster, called "Champ," in the lake, which has a depth of more than four hundred feet. Champ is believed to be related to an extinct aquatic reptile called the plesiosaur. Reported to be between twenty-five and thirty feet long, Abenakis called her Tatoskok. In 2003, Fauna Communications Research Institute conducted a recording of echolocation, registering sounds resembling a beluga whale or an orca.

The county comprises Belvidere, established in 1791; Cambridge, 1781; Eden, 1781; Elmore, 1781; Johnson, 1792; Morristown, with a village called Morrisville, 1781; Stowe, 1763 (Stowe encompasses the village and town of Stowe, as well as the lower village and the hamlet of Moscow); Wolcott, 1781; Waterville, 1781; and the shire town of Hyde Park, 1781. In the 1870s, Hyde Park was home to the world's largest calfskin tannery with the arrival of the Lamoille County Railroad.

There was a major fire in Hyde Park in 1910 that destroyed the Congregational church, an elegant Gothic structure with turrets and arched stained-glass windows. It was rebuilt in 1912 and is still a place of worship today.

Each town in Lamoille County has its own individual flavor, although within the county, everybody knew everybody, and today, among the locals, they still do it seems. The three Lepine brothers discussed the current climate of living and hardships of the times. Irenee was farming in Hardwick and Wilfred in Sterling Valley, in the foothills of Sterling Mountain at the foot of Bull Moose.

Gert said, "Someone sighted a bull moose on that hill one foggy morning, and that's where the name came. Now there are a lot of moose up there."

At the time Wilfred and Irenee were farming in Vermont, dairy products were in high demand, Vermont being the leading supplier of milk to the metropolis of Boston, Massachusetts, shipped south on trains. Irenee and Wilfred were making a living in Vermont.

Gert said, "Another factor was that FDR was paying so much for farmers not to raise pigs or sell cows." Irenee offered Maurice and his family a place to live on his farm while Maurice searched for a farm for his family.

THE LEPINES BID
FAREWELL TO CANADA

Give me your tired, your poor, your huddled masses yearning to breathe free, the wretched refuse of your teeming shore, send these, the homeless, the tempest-tost. I lift my lamp beside the golden door!
—excerpt from "The New Colossus" by Emma Lazarus, inscribed beneath the Statue of Liberty, 1903

On May 30, 1930, the Lepines bid farewell to Canada, traveling in a southeasterly direction to Vermont (French: *vert*, green; *mont*, mountain). The Green Mountain State was officially named Vermont by the state's first governor, Thomas Chittenden.

The Lepines rode the tail end of a mass migration to the beautiful state that began in the late 1800s and ended in the early years of the 1930s. They soon realized that Vermont had many similarities to Quebec. It was mountainous and hilly, with clear lakes and streams and miles of farmland. Uncle Wilfred came up to Canada by car and picked up the Lepine family.

Marie, being the oldest, remembers it best. She said, "We emigrated through Sherbrook, Quebec. Went through customs. We had our immigration cards. They asked my folks a lot of questions. We came into America through Derby, Vermont." Arriving at Irenee's, Papa began looking for a farm and purchased a dairy farm in the neighboring town of Hardwick.

Maurice was a Francophile with a limited English vocabulary. His was a typical conversational vernacular. "How are you? Thank you very much. Goodbye. How much is that? What time is it?" Imelda spoke French but no English.

Gert said, "I remember one time, we had some visitors at the farm. As they were leaving, Mama waved goodbye, saying, 'Hello! Hello!'"

Mama enrolled her "young'uns" in a one-room schoolhouse in Elmore—all but Jeanette, who was too young for school. Lawrence wasn't yet born. The school sat at the foot of Elmore Mountain near the glacial Lake Elmore, where the Lepines chopped ice for their icehouse. Jeanette said, "Everybody had their own icehouse in those days. Mama and Papa used to cover it with sawdust, and it wouldn't melt in there. How else were we going to keep the milk cold?"

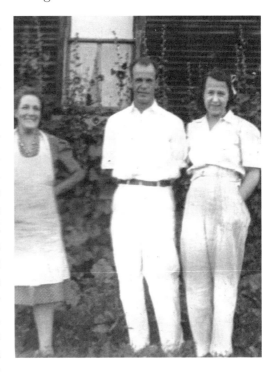

Mama and her French Canadian cousins—Roland and Evonne Buler—in Montreal.

Lamoille County was residence to many one-room schoolhouses. Typically, the youngest student was six and the eldest sixteen. The teachers were older teenagers. Students were seated chronologically by age—the youngest in the front and the oldest in back. On cold days, a wood-burning stove kept everyone warm. "Reading, 'Riting and 'Rithmetic" were fundamental to the children's growing intellect, creativity and sense of well-being.

The kids adored Euretta Smith, or Tico, as they called their teacher. She was a young, vivacious girl. She fed them candy stashed away in the pocket of her dress. She taught the Lepine children English by labeling illustrations: chairs, baskets, spoons, crayons, puppies, sheep, cows, pigs, pumpkins, pies, mountains, streams, trout, tractors, woodpiles and snowflakes. A big red, white and blue American flag in the corner of the room was saluted in the morning, followed by the Lord's Prayer.

Wilson "Snowflake" Bentley's book *Snow Crystals*, illustrated with more than 2,400 images of snowflakes, had just come out. Many Vermont children were learning more about snowflakes than ever. Children in

Vermont learned that "Snowflake" was born in Jericho, Vermont, spending his life there. From a young age, he was fascinated with snowflakes and invented a photomicrograph. When it snowed, he caught snowflakes on a glass plate. He said the greatest moment of his life was when he created his first photomicrographs of a snowflake. He found that these exquisitely beautiful snowflakes were each unique. No two snowflakes were alike. He photographed frost, and it appeared like gracefully designed lace.

Snowflake wrote, "Under the microscope, I found that snowflakes were miracles of beauty; and it seemed a shame that this beauty should not be seen and appreciated by others. Every crystal was a masterpiece of design and no one design was ever repeated. When a snowflake melted, that design was forever lost. Just that much beauty was gone, without leaving any record behind."

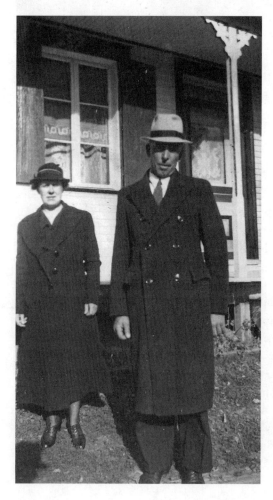

Uncle Eli and Tante Florida, St. Pauly Carp, Quebec.

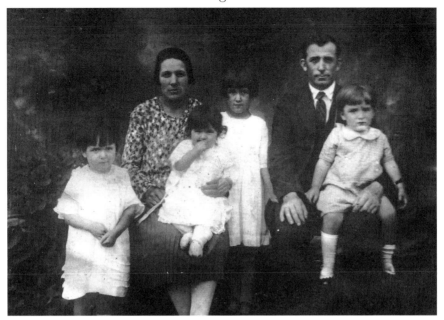

The young immigrants: Mama and Papa Lepine. The children, *left to right*, are Therese, Gert, Marie and Andre.

In time, jewelers, engravers and people in the textile business voraciously sought his images. Although he traveled to Burlington and other parts of Vermont photomicrographing snowflakes, he found that Jericho had the most elegantly designed.

Besides prose, poetry was taught in many Vermont schools. A popular poem was "Stopping by Woods on a Snowy Evening," by Robert Frost, Vermont's poet laureate.

> *Whose woods these are I think I know.*
> *His house is in the village though;*
> *He will not see me stopping here*
> *To watch his woods fill up with snow.*
>
> *My little horse must think it queer*
> *To stop without a farmhouse near*
> *Between the woods and frozen lake*
> *The darkest evening of the year.*

He gives his harness bells a shake
To ask if there is some mistake.
The only other sound's the sweep
Of easy wind and downy flake.

The woods are lovely, dark and deep
But I have promises to keep,
And miles to go before I sleep,
And miles to go before I sleep.

At the Elmore one-room schoolhouse, chores were delegated to students: filling inkwells, bringing in armloads of firewood and stacking them in a bin by the stove, clapping erasers and wiping down the blackboard (a learning tool invented by Reverend Samuel Reed Hall, one of the finest men of the American educational system, born in Concord Corner, Vermont).

The Lepines wore jeans made of grain bags. Jeanette recalled years later, "Mama dyed them brown with the skins of butternut shells."

Gert said, "They were made of pure fabrics. Not like polyester. Natural fabric."

The Lepine family got into a rhythm as families do. But rhythms change with time, like the rhythm of the seasons, and one afternoon when the kids arrived home from school, things were different. Mama was lying in bed. An oddity to the kids, for she was never sick and always busy. The kids often wondered when she slept. Out of the blue, the country doctor came out of Mama's room and left the house carrying a black bag.

Gert was a curious six-year-old at the time and recalled years later, "After a while, we heard a baby cry. We all went in to see Mama. She was in bed holding Lawrence, our new baby brother." Gert asked, "How'd the baby get here, Mama?"

Mama asked, "Didn't you see the doctor carrying the bag?"

Gert thought, "Oh well, that's the way they come, I guess, in a black bag."

Winter temperatures dropped deeply, as they still do. Snowflakes, sparkling ice, cold blue skies, blustery winds and the luminous shine of the moon made for a landscape of wonder and delight when one is warm. Mama kept her children comfortable with quilts and fires in the wood stove. Snowstorms lasted for a week or more, with upper elevations receiving as much as 120 inches over the course of a winter. The year 1933 was the coldest winter ever recorded in the state of Vermont, at minus forty degrees Fahrenheit.

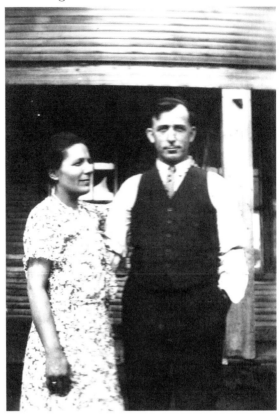

Mama and Papa Lepine at their family's farmhouse in Hardwick, Vermont.

People were so poor they were filling holes in their shoes with cardboard, pieces of cloth and rubber from worn-out tires. Gert recollected years later, "Papa was losing our family's farm in Wolcott. He got an offer to milk cows in Colchester. My folks decided to rent our farm to a farmer who promised to care for the cows and the farm as if they were his own."

The Lepines traveled west to Colchester, earning enough money over the winter to plan ahead for a future back on their own farm, counting the days until they could return. They left for home on a day that was supposed to be spring, but the frigid morning was so cold that it could snap the joints of one's fingers and toes like twigs off a branch—bone cold, a chill that knew no mercy.

Gert recalled, "When we arrived home, we stayed overnight at the Joneses' while our farmhouse warmed up with a good fire in the wood stove. I remember, they had these rollaway beds. I really liked that."

Papa shivered at the sight of the barn, in ill repair and disarray. Lighting up a hand-rolled cigarette, he took a deep drag. The cows were ravaged.

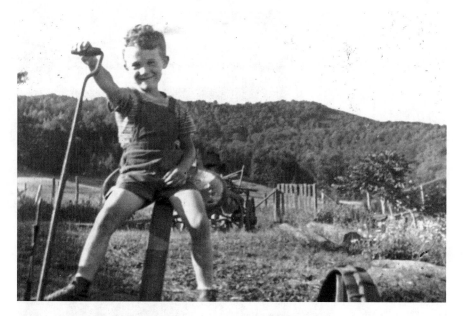

Raymond, Mama's cousin from Montpelier. He and his family often came to visit at the Lepines' farm.

Frozen cow manure lay in broken trails across the floor. Papa traced the animals' ribs through frosted, dull coats and began to perspire in the cold, dirty barn, wondering what to do next. He called Mr. Wolcott to see if he had any hay. He had. Maurice made strides to this neighbor's farm, a good mile away, his breath a smoky frost.

Gert recalled, "Papa ran a high fever that night. The next morning, Mama called Dr. Stevens. He didn't do much. Left Mama with a death certificate. We were all staying at the Joneses'. Mr. Jones brought us home when Mama called him."

Marie said, "She gathered us all 'round Papa's bed and then she told us to pray. She asked me to put my head on his chest and listen to see if he was still breathing. I told her I could hear him breathing."

Mama said, "I hear there is a new doctor in Morrisville."

Marie recalled years later, "Mama and I harnessed the horse, and we went to pick him up at the Elmore Store." He came in the house with Mama and Marie. The other children were still kneeling on their knees around Papa's bed.

Gert said, "Dr. Stevens put some whiskey to Papa's lips, and Papa responded."

Even though prohibition was still in force in the United States, medical alcohol could be used and prescribed by doctors for their patients.

WHEN A MIRACLE OCCURS

You shall be free indeed, not when your days are without a care nor your nights without want and grief, but rather when these things girdle your life and yet you rise above them, naked and unbound.
—Kahlil Gibran

Gert said, "After that illness, when Papa really had died, and I mean really died, he was never the same. He was very weak for a long, long time."

Mama was now the head of the Lepine household. Once again, Maurice and Imelda were losing their family's farm. They were part of a majority. Between 1930 and 1934, more than 1 million families in the United States lost their farms. In 1932, 273,000 American families were evicted from their homes, and 2 million homeless drifted around the country. The government classified 60 percent of Americans as poor.

Mama asked for help from local public authorities, but she was turned away and told to go back to Canada. At school, Marie confided in Tico, "Mama and Papa have lost our farm and we must return to Canada."

Tico said, "No, that's not true. You are my students and I care for you. I'm going to help you. Tell your Mama, Tico is her friend." After school, Tico called on the neighbors. At her advice, the neighbors offered Imelda food from skimpy cupboards and their children's secondhand clothes. Her neighbors' generosity and moral support bolstered Imelda's strength. She seized the day, setting her mind to being the best at all she endeavored, teaching her children the value of hard work and the independence and

great feeling of accomplishment that work brings to a person, a home and a family. Vermont was now home to the Lepines from then on, and the family would make their mark, returning goodness for goodness received.

Uncle Wilfred Lepine was still tenant farming for Francis Clark in Sterling Valley. He invited Mama and Papa to come stay with him. This would give Maurice a chance to recuperate while providing the family a home and plenty of work. The farm encompassed 150 acres.

The valley had cold, clear waterfalls, brooks and streams and the Sterling Gorge, with eight drops totaling one hundred feet, as well as the strikingly beautiful mountain views of the Sterling Range. Wildlife thrived there, as well as edible plants and berries, all becoming part of the family's diet. There were no deer at the time, though.

It was a day in May, with all its breezy coolness, when Imelda and Maurice packed up and piled the kids in the horse-drawn buggy, going up to live in beautiful Sterling Valley. It was a paradise. The farmhouse and barn were next to each other. Gert said, "We saw Santa Claus land on the roof from our window. We really thought we did." They had such vivid imaginations!

Come spring, the meadows were dressed in dandelions and myriad shades of green, as if first cousin to the Emerald Isle. Above and beyond the grass and plowed fields was Mount Mansfield, still wearing snow on its ski trails. No wonder Maria von Trapp saw hints of Austria, her native land, in Stowe.

Hedgehogs timidly scampered through meadow grass, nibbling here and there. Young red foxes stayed near to mother while she hunted for food. Black bears plodded out of hibernation—ravenous, lumbering mamas ready to give birth. Brooks gurgled the news, "The earth is reborn!"

The Lepines bought a herd of sheep. Sheep shearers were earning fifteen cents per sheep, but Papa chose to shear the Lepines', and Mama sent the wool off to Harmony, Maine, where it was spun into yarn. She became adept at braiding rugs out of rags, cutting clothes out of remnants, caning chairs and knitting sweaters, socks and mittens with wool from her sheep. Her hands and creative mind were a blessing to all that she touched.

Mama got the local news over the telephone. Years later, Gert said. "Ours was a party line of eight families. My family's signal was four rings, a pause and then two more rings, but when the phone rang, no matter how many rings, Mama would always rush to put the earpiece to her ear, listening carefully with an appetite for the latest news. That's how everyone got the news back in those days, up in these parts, ana-way." In Stowe, the telephone operator was Mrs. Straw, from 1911 to 1939, when she retired at the age of eighty-one. Until the dial system was installed in town in 1954,

other telephone operators followed Mrs. Straw. About 530 telephones were switched to dial phones on March 28, 1954, at noon in the area.

Wilfred soon moved south to Gaysville, Vermont, a southerly and pastoral farming community, leaving Mama and Papa to take over the farm. They were familiar with their new surroundings.

In the buggy with the kids and a "giddy up!" they took a ride from their big farmhouse down Ron Terrill Road to West Hill Road, descending to the quaint little village of Stowe, a year-round resort, a place of beauty, recreation, friendly people and a growing commerce. Tourists mixed in among the locals, who gladly accepted their cash in trade for services rendered and local products. This trend has never changed.

Out-of-towners took solace in Stowe starting before the beginning of the Great Depression, riding in on the train via the Mount Mansfield Electric Railway to the bordering town of Waterbury, where they'd catch a cab into Stowe or drive their own automobiles.

Woodies, mostly sedans with the rear body work created of wooden frames and in-filled wood, were an elegant sight on the country roads among other shiny, well-detailed automobiles. Convertibles were a popular item.

In the 1930s, there were seven or more filling stations in Stowe. There was a filling station called Tydol-Veedol, across the street from Lackey's General Store, and a pump at Shaw's General Store, where the saying was "Cash talks loud." Shaw's was opened by one of Stowe's primary entrepreneurs, Howard Shaw. There was an Esso Station at the junction of Mountain Road and Main Street. Gas was twenty cents a gallon. Gas station attendants pumped a patron's gas, washed the windshield and checked the fluids with a smile. The attendant was quick with directions, too: "Ayep, you can git there from hee-aa."

Tourists checked in at the Green Mountain Inn in the village. The inn is known to be haunted by a tap-dancing ghost named Boots Berry. Boots was born at the inn, the son of the liveryman and the chambermaid. He died rescuing a young girl when he fell off the roof in his attempt. He obviously has a strong attachment there, for many people have heard his rhythmic footsteps as he's danced across the bedroom floor of his childhood. Memories linger for us all.

The inn dates back to 1893. Thomas Edison was a guest, and Gerald Ford stayed there while modeling for a piece on Stowe for *Look* magazine, before his political days. Pictures of him show a young Ford smooching a glamorous blonde who rendezvoused with him at the inn. In the 1950s, Parker Perry was a popular innkeeper at the inn. He drove around Stowe in a woody with his Saint Bernard named Caesar.

Locals graciously and gladly opened their doors to out-of-towners, their homes serving as guesthouses, putting much-needed money in their worn pockets. The Lemaire family—whose farmhouse is on the Mountain Road, a big, old beautiful place, now painted yellow—took in guests for two dollars a head. This became a local tradition, and bed-and-breakfasts became part of the regional flair. The Lemaires' farmhouse was sold and for a while was Whiskers, a restaurant with floribunda perennial gardens surrounding the building. It was turned into an office building and now is up for sale.

The tourists back then enjoyed dairy products as part of their daily fare. Mama and/or Marie transported the family's cows' milk, cream and butter from the Lepine farm in Sterling Valley to the Mansfield Creamery, located on the lower Mountain Road in the village.

Jeanette said, "Mama put the milk through a hand-worked cream separator, pouring it into ten-gallon milk cans, refrigerated by ice blocks in water in a large, insulated tank. She was now ready for transporting it by buggy or by sled over the five-mile road up West Hill, down Weeks Hill to Stowe to the Mansfield Creamery on the Mountain Road."

Mama steered her horse past the old Percy farmhouse on the corner of Weeks Hill and Edson Hill, still a working farm to this day. Paul Percy lives in the old gray farmhouse where he was born, across the street from the barn. His Jerseys are a daily sight, eating clover and grass in the meadows. The school bus, cars, trucks and tractors are often delayed as the cows cross Weeks Hill back to the barn in the afternoon for milking.

The building that housed the creamery in Stowe still stands today in all its old New England style. It became the Yodler Inn, known for the "all you can eat" buffets. Currently it is the Stowe Inn.

Mama and the kids milked the cows by hand at six o'clock in the morning and again at five o'clock in the afternoon with a gentle respect. Jeanette said, "We knew each individual udder."

Folks in Lamoille County used native lumber, brick and stone to the maximum. Back then, all of the buildings, walls and covered bridges in Stowe were made from local natural resources.

EARLY DAYS ON THE FARM
IN STERLING VALLEY

There was a sound beside the wood but one, and that was my long scythe whispering to the ground.
—Robert Frost

In Sterling, the Lepine children became students at the Cole Hill Schoolhouse in Mud City. Gert said, "We went to Cole Hill to finish the school year from our schooling in Elmore at the 'Pond School.'" She added, years later, "We always went to school then in a sleigh, you know, like Santa Claus's, or a buggy. We pulled them with our horse. We had our blind mare, Dolly. There was a building at school where we kept our horse and buggy or sleigh. We would go out and water our horse during the day."

Jeanette said, "It was a thin sleigh with tin runners. Your butt was always hanging off the side."

Gert said, "One time, Molly was pulling us in the sleigh, and because she was blind, she missed the turn and went over the bank. Jeanette hit a tree with her face and broke her nose. Little Lawrence kept yelling, 'Are you dead, Jeanette? Are you dead?'"

Jeanette said, "The swelling didn't go down for three days."

"Miss Mateleinan was our teacher. She was a first-year teacher and *green*!" Jeanette said about their school. "The class was made up of me and Gert, Andre, Robert Allen, Vance McConnell, Albert Allen and Lance Allen. Sometimes, little Lawrence would come to school, and the teacher would babysit. He was four years old then." Jeanette added, "That was on days that Mama had to go to the creamery. He used to love to chase butterflies. At the

end of the school day, Miss Mateleinan led the class in singing, 'God Bless America,' and then said, 'Goodnight, children.'"

Gert said, "We answered loudly and in unison, 'Goodnight, Mrs. Dandelion,' bringing Miss Mateleinan to tears as we all laughed, jumping out the open windows, headed for our horse and buggy or sleigh."

When the Lepine family traveled into the village of Morristown, they'd cross the Red Covered Bridge, now listed on the National Register of Historical Places. Bridges are covered to protect them from heavy weather, and so it stands to reason that Vermont has more covered bridges than any other state in the country.

In Lamoille County, the following covered bridges still stand: in Morristown, the Red Covered Bridge; in Belvidere, the Mill Bridge and the Morgan Bridge; in Cambridge, the Gates Farm Bridge; in Cambridge Junction, the Grist Mill Bridge; in Johnson, the Power House Bridge and the Scribner Bridge; in Waterville, the Village Bridge; and in Stowe, Emily's Bridge or Gold Brook Bridge. This last bridge is haunted by a young woman's ghost. She was supposed to meet her lover, and they were going to run away and get married. He never showed. Heartbroken, Emily hanged herself from the bridge. She's known to angrily claw at cars that pass through the bridge, leaving scratches.

The Red Covered Bridge was built in 1896 and bridges a narrow gorge. The bridge connects Sterling Valley Road to Cole Hill Road in the Stowe section of Sterling Valley. Exposed bedrock cliffs give it a timeless quality.

Hidden in the dark, cold pools of Sterling Brook are brook trout, called "brookies." The hungry fish jump up, opening their mouths wide, snapping at mayflies performing mating dances over the water. The presence of trout in a body of water indicates that the water is pure and the fish clean, nutritious and flavorful to the palate. There was a brook at the farm where the Lepine kids fished. Gert said, "Sometimes we'd just catch 'em with a bucket."

Cut off from the world by the Green Mountains, the Lepines developed a deep sense of self-reliance. Freedom and independence became a guarded passion and a way of life.

Samuel R. Ogden said, "The hardest job of all jobs is farming," listing the following attributes for a successful farmer: agronomist, husbandman, businessman, mechanic, carpenter, plumber, mason, electrician, rigger, roofer, meteorologist and veterinarian. Mama and her kids did it all.

There was no electricity in Sterling Valley or in any of the backwoods areas. That meant, of course, no refrigeration, running water, toilets or bathtubs. Everyone had an outhouse. Everything had at least two uses.

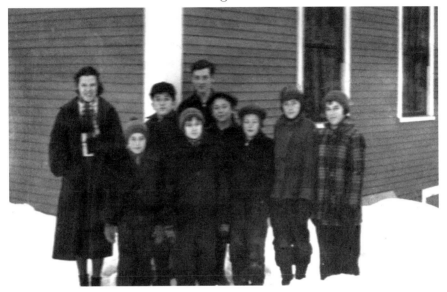

The Cole Hill one-room schoolhouse, Morristown, Vermont, with Miss Mateleinan and her students. The Lepine children are in checkered hats.

Outdated Sears and Roebuck catalogues sufficed as toilet paper. Gert said, "At first the catalogues were made of regular paper and that was all right, but when they changed the catalogues to shiny colored paper…errr."

Darkness set in early come wintertime. The first day of winter arrives with the winter solstice, December 21, and by 4:30 p.m., darkness came over the mountains, into the hills and over the land like a blanket. The flicker of light from kerosene lanterns, candles, fires burning in fireplaces, red-hot coals in wood stoves, bright stars and the light of the moon punctuated otherwise ebony nights.

Farmers were still a pre-urbanized, pastoral society as the world became industrialized. Their tools were milk buckets, milk cans, scythes, harnesses, axes, hoes, logging bobs, hog hooks, traverse sleds, cross-cut saws, wrenches and plows.

It is thanks to Vermont statesman George David Aiken that Vermont farms modernized. He is one of Vermont's most important figures. A horticulturalist and nurseryman born in Putney, Aiken arrived on the political scene, "Vermont-i-sizing" the governing climate with progress for farmers. In 1937, he was elected as Vermont's governor and served in this role until 1941. Therese Lepine was a schoolgirl then, still unaware when she left the family farm that she would one day work closely by Aiken's side at his

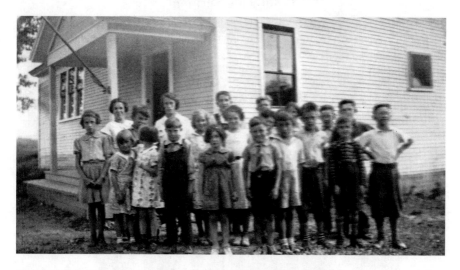

The Cole Hill schoolhouse, with the Lepine children in attendance.

office in Washington, D.C., as his secretary. She said, "He wanted a girl who knew all about agriculture."

He was known as the "farmers' governor," for he assured them that they could make better lives for themselves through co-ops—a venue for selling their wares independently and in bulk. He made it possible for electricity to be installed out in the wilderness of the hill farms.

But until he did, Mama Lepine found that fire was her true friend. The wood stove served many purposes: cooking, canning, doing laundry and heating rocks to warm her kids' feet on a sleigh ride. She had a boiler on the back of it and, as Gert described it, "a very special stick for stirring laundry and she had two tubs with a ringer in the middle and a washboard. She made laundry soap from borax and lard."

Her clothesline wore clean laundry, drying in many kinds of weather, making a pattern across the line against the horizon. Dressed in worn blue jeans, the family worked a herd of twenty cows, rising early to an animated chorus of moos, oinks, squeals, cackles and cock-a-doodle-doos. The kids grew up on luscious raw cow's milk, and Gert and Jeanette still drink it.

Jeanette said, "It tastes so rich and creamy. We wouldn't have it any other way. There is such a difference in taste between raw and pasteurized milk. Raw milk is so much creamier and flavorful."

Raw milk is known to have medicinal uses, as well as good clean protein. Cows were grass-fed, and the milk was pure. From ancient times up until just after World War II, raw milk healed millions of people of their ailments.

It contains all of the essential amino acids, vitamins, minerals and calcium, as well as having antibacterial properties. A person could live solely on raw milk, and many have.

In those days, people were quite self-sufficient, growing their food and making do. It was common for a woman to make her children's clothing. Mama had a treadle sewing machine powered by her foot and her hands. Treadle machines are sensitive to the touch and works of art in and of themselves. Mama loved her sewing machine, designed from wood and metal. The foot pedal was metal and intricately detailed. One of Mama's creations was a soft tobacco pouch for Papa made from a pig's bladder.

Gert said, "A friend of Mama's, also an immigrant from Canada, Mr. Blainechette, gave her a lot of houndstooth checked cloth, as well as rayon, which Mama considered quite fancy. With the houndstooth check, she made each of us girls a jacket and a matching hat. She made Jeanette a pretty yellow dress with the rayon. At the Cole Hill School, Jeanette climbed a tree and ripped the dress. Boy was Miss Mateleinan mad! She said, 'You've ruined the beautiful dress your mother made for you!'"

Mama's sewing machine is still in the Mount Sterling farmhouse today, in the dining room. It is so very lovely. Shouldn't every woman inclined to sew have a treadle machine? It allows for free motion and one's own creative pace. It's a quilter and embroiderer's dream come true.

The catalogues from Sears and Roebuck and Montgomery Ward, before they were used as toilet paper in the outhouses, brought the world of consumerism to the farms. Montgomery Ward had masterminded the idea of bringing quality merchandise to the country folk in the 1800s through the U.S. Mail. The mail was delivered by train. The company offered the popular "satisfaction guaranteed or your money back" policy, and the voluminous catalogue was known as "the wish book."

Sears was the company's first competition, arriving on the scene in 1896. Sears went on to become Sears and Roebuck, making available by mail-order automobiles, clothes, sewing machines, groceries, bicycles, dolls, refrigerators and, as Gert would find out, even roller skates.

Mama bought the family's blue denim and work shoes by mail order, purchasing dungarees sized with the longest inseams, no matter who would wear them. Vermont had rural free delivery, and when the package came in the mail, upon opening them, she measured the length of the denim she ordered for each family member, cutting off the excess cloth to fit the individual's leg length, sewing a new bottom seam on her treadle machine and saving the remnants for patches and denim caps for the children.

S&H Green Stamps made for another type of catalogue she used to purchase things for the farm. Stores would offer them to the customer. The more money spent, the more green stamps the consumer received. Mama saved S&H Green Stamps, pasting them in the little green stamp books. She saved her books until she had enough to order something she wanted.

The company was established in 1896 and was at its most popular in the 1960s, issuing three times the number of stamps issued by the U.S. Postal Service. It was the largest publication in the United States at the time. Mama shopped at Morrisville Lumber, a store owned by an Italian immigrant, Bruno Loati. Mama had earned $800 worth of green stamps and set her sights on purchasing all the siding for the farmhouse.

Bruno said, "But Mrs. Lepine, you don't understand. I don't give green stamps for such a big item. It's store policy."

"Store policy? I have been saving my green stamps a long time for the siding on my family's farmhouse. It's very important to me." They dickered back and forth over the phone. It was kind of a game to them, really. This went on for a period of time, and Mama wouldn't budge. She finally wore old Bruno down.

"All right, Mrs. Lepine, you win. I will give the green stamps, all $800 of them. Come on in to Morrisville Lumber and pick them up. I'll have them for you in a big bucket. And you can lick every single one of those stamps and put them in your S&H Green Stamp books for your siding!"

"My family and I thank you, Mr. Loati!" Gert drove down in her pickup truck and picked up the green stamps. Mr. Laoti had them in a big sap bucket.

Gert said, "She licked each and every one and brought them back for the siding. It's still on the farmhouse today."

Jeanette said, "After everything she went through, it made her strong and determined. She'd never be poor again. And she stuck up for herself and us of course. Tough little lady, she was. Had to be."

There is an old canister set in the kitchen from Mama's green stamp days. The habit of consumers using S&H Green Stamps infiltrated popular culture. For instance on the television series *The Wonder Years*, which aired on television years later, Norma Arnold tells her husband, Jack, that she bought the coffeepot she was using for the Christmas party with green stamps.

Mama had her own canning jars and gardening tools. In the summertime, she and her children picked strawberries in the meadows at the Sterling Valley farm, where berries grew profusely.

Gert said, "Us kids would find a good spot and pick for hours."

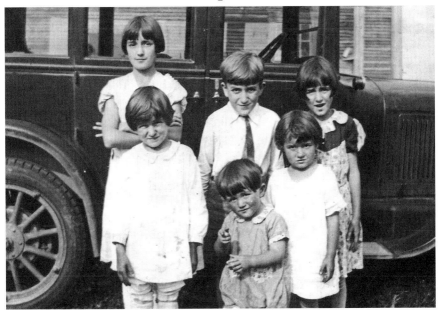

The Lepine children in front of the Oldsmobile that Papa bought but never drove. Marie said, "We used it as a playhouse." *Back row, left to right*: Marie, Andre and Therese. *Front row, left to right*: Gert, Lawrence and Jeanette.

Each summer, Mama canned two hundred quarts of tomatoes, a variety of vegetables and forty quarts of strawberries, and canning wasn't for sissies. It involved extremely hot and sticky kitchens, where the canner never left the stove. It was a job of precision, so as to prevent botulism and keep food fresh for months to come, a job for the intelligent and the tough. Jeanette said, "Mama even canned meat. She'd parboil it first."

During the summer, Mama picked from the garden: sweet corn, plump tomatoes, potatoes, green beans, Swiss chard, sweet peas, juicy beets and cucumbers for eating and pickling, fat red radishes (on which they'd sprinkle salt), onions, garlic, carrots, spinach and bell peppers.

Mama proofed her yeast, kneading and baking loaves of bread. She fed her family year round with her provisions and also sold them as part of her entrepreneurial pursuits. The destitution she had experienced may have become just a memory, but Mama learned never to waste *anything*. And as the old adage states, "Make hay while the sun shines."

Indigenous people's diets are intricately related to their environment. When it was time to kill a cow because she hadn't given enough milk to keep her, Papa butchered her, cutting the sweetbreads out after the kill.

Sweetbreads, the thymus glands found in the neck and near the heart, need to be used within twenty-four hours. Papa handed these delicacies over to Mama. Jeanette said, "She made blood sausage with them."

The Lepines were all hunters. Jeanette had a little .410-bore shotgun, the smallest of conventional shotguns, with a low recoil—great for a young girl with a good aim. One summer afternoon, in between barn chores and milking, she headed out into the thick of the woods. In time, she came running back from the forest, her gun in one hand and two pieces of game held tight in the other, her dark hair wildly askew.

"Hey, Mama! Gert! Lookie here at what I shot. A gray squirrel and a woodcock!"

"That's no woodcock, Jeanette," said Mama. "You shot yourself a pileated woodpecker."

"No good?" Jeanette asked.

"Why, it's *very* good. Now, go pluck the bird and skin the squirrel, and I'll cook 'em up for dinner." At supper, Jeanette beamed. She thought to herself that if she were ever to eat at a restaurant in the village, this woodpecker would be quite worthy of the menu.

MORE STERLING
VALLEY TALES

One of the best things about folklore and fairy tales is that the best fantasy is what you find right around the corner, in this world. That's where the old stuff came from.
—Terri Windling

In the 1930s and '40s, there were no fences in Sterling Valley. Often, the Lepines' cows took to wandering up Bull Moose Hill, seeking a change of scene and tasty vegetation, like red clover, Vermont's state flower. Gert, Jeanette and Andre would hike up, herding the bovines and coaxing them home, working as a team. Sometimes, Gert and Andre herded, or Jeanette, Therese and Gert.

"Jeanette's a natural herdswoman," Gert said.

On one of their hikes up Bull Moose Road, Gert and Jeanette noticed an old barn had been torn down.

"Hey Jeanette, we could use some of that wood and all the nails."

"What for? The nails are crooked, Gert."

"We can straighten 'em out and make something for Mama."

"That's a great idea. Let's surprise her. She's always making jelly. Why don't we make her a jelly cupboard?"

Gert and Jeanette spent the rest of the afternoon straightening nails and cutting wood with a handsaw. Mama was delighted when they gave her a handmade jelly cupboard. She kept it stocked with her sweet fruit jams and jellies. When I was writing this book, I visited with them. We got to talking about the jelly cupboard.

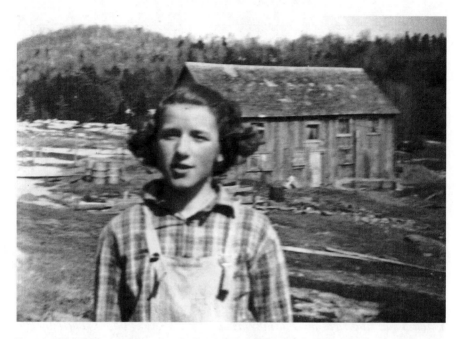

Jeanette, age eleven, at the Lepine farm in Sterling Valley, Vermont, with the old horse barn in the background.

Gert said, "We still have it. It's down in the cellar if you want to see it." I said I would the next time, when I returned to visit again the next day. Gert said, "You'll have to go downstairs to see it. I'm not bringing it up. It's full of stuff."

We talked about the summertime in Sterling. The kids hayed with draft horses, barefoot all summer long. A pair of shoes *had* to last the school year. On hot summer days, spruce sap ran pink. The kids chewed it like gum. Maple trees turned shades of red and orange and birch leaves to gold, fluttering against vibrant blue skies like pieces of music, strung out in the harmony of God's symphony and the harvest that had come: orange pumpkins, blue hubbard squash, spaghetti squash, cabbage, apples, lettuce, turnips, cauliflower and broccoli, with cider pressed and wood stacked neatly for the coming winter.

At night, the world was silhouetted by the old harvest moon, lemon yellow or the color of a white star, all big and bold, lighting the meadows and fields and silhouetting the trees and the mountainous horizon like magic. Harvest time meant that it was time to go back to school.

The Lepines walked through the Marstons' meadow that first morning as the crickets sang, up to Billings's one-room schoolhouse. The five of them

Papa tapping a maple tree at the
Lepine farm in Sterling Valley.

warranted this school to open when added to the number of neighborhood
kids there. They reminisced about their first summer at the Sterling Valley
farm, wondering about their new school and teacher, Miss Vance.

The shyness the Lepine children felt as newcomers to Vermont had
disappeared. They were Vermont country kids now, learning from the
brazen, experienced eighth-graders in the one-room schoolhouse. When the
teacher aimed to teach them to throw a ball, they all laughed. Jeanette said,
"We could throw a ball better than she ever could."

Gert said, "Andre was quite a brilliant student, absorbed in books. He
loved Jules Verne's *Twenty Thousand Leagues Under the Sea* and *Robinson Crusoe*,
by Daniel Defoe." Defoe is recognized as the first published and widely read
novelist in the English language.

"Andre was expelled for bad behavior for calling a female schoolmate a
heifer, Victoria Godin," Jeanette recalled with a smile. He said, "I apologized

to the old heifer. Don't get so mad!" Years later, Andre was expelled from the University of Vermont. He was attending a graduation ceremony there with a friend. Before it began, they realized that there were two empty seats on the stage among the dignitaries. The two of them decided to go sit on stage and join the distinguished and honorary guests.

Gert said, "He had to beg to get back into the school."

Jeanette said, "It's always the super-smart ones who get in trouble." Andre became an agriculture teacher in the state of New York.

At the Billings School, Miss Evelyn Slayton held talent contests. Jeanette won first place with little Lawrence. She sang to him, "Oh where have you been, Billy Boy, Billy Boy? Oh where have you been charming Billy?" Then Jeanette would give Lawrence a jab, and he answered, "I have been to see my wife, she's the joy of my life. She's a young girl and cannot leave her mother." Jeanette said, "We won first prize! A chocolate bar."

Gert said, "I got up in front of the class and put on a skit. I asked the class, 'Who was the greater? Abraham Lincoln was great. George Washington was great. But here is a grater!' I held up a grater. I won second prize, a Mr. Goodbar. Miss Slayton was great. She taught the boys

The Lepine kids' school pictures taken up at the Cole Hill one-room schoolhouse in Sterling Valley. The class was bobsledding.

to play guitar and sing. She had a friend up in Stowe Hollow, he was the emcee, Loyd Douglas."

Gert recalled, "There was a privy out back. One for the girls and one for the boys. One time I looked down, and there was Albert Allen looking up at me from across the rocks!"

We talked about how they spent their recesses. One day during recess, the Lepine kids rollicked among wild leeks. When the bell rang, they ran back into the schoolhouse. The school board was holding a meeting when suddenly the members were overpowered by the garlicky scent of country kids, ripe from the wilds.

The Lepine kids knew the woods and what it held, eating beechnuts and setting snares for snowshoe rabbits in winter. Gert said, "We were trappers. We'd soak a small piece of cabbage in salt and attach it to a piece of string. We baited the hares by balancing a box with a stick that was attached to the string. Then we'd go home. When a rabbit went in to eat the cabbage, the box would fall on top of them and trap them. We'd go check our traps the next day, and there'd they'd be. Those rabbits had strong back legs and gave us a good fight."

Marie said, "Mama made a wonderful rabbit stew."

Jeanette said, "Our favorite game was called 'Wild Man.' That's how we passed the time at recess and sometimes past recess. The 'Wild Man' had to run and hide and be found by the others. Sometimes, when the bell rang, we'd pretend we didn't hear it. The Wild Man stayed hidden in woods while the rest of us searched. There were so many trees and places to hide."

Fall evenings found Mama sitting next to the wood stove, knitting needles clicking. Marie said, "Besides knitting for us, she was selling the extras to the neighbors. Mittens were a dollar a pair. She also bartered."

Gert said, "She traded a pair of mittens with Frank Sweetser for one of his beautiful egg baskets that has lasted forever."

In Canada, New Year's Day was the most celebrated holiday, but it wasn't long before the Lepine kids came to love Christmas in New England. Cutting down a Christmas tree, they dragged it home through the woods, singing Christmas carols and telling stories of Old Saint Nick. Decorating the tree as the kids were nestled in the house, they soon were thumbing through the well-worn pages of the Sears and Roebuck and Montgomery Ward catalogues, dreaming of Christmas presents for hours at a time.

The Christmas season came to have a special meaning to the Lepine children. Some years, Santa Claus brought oranges! Juicy and exotic. Some years, Santa hadn't a red cent. That's when the kids played Santa's helpers.

The interior of the restored one-room schoolhouse next to the Helen Day Art Center and Stowe Free Library in Stowe, Vermont.

Pooling their money, they offered their stash in the spirit of Christmas and to Saint Nick's helpers, their Mama and Papa. When they had a really good year, Mama would spend lots of time in the kitchen, cooking and baking recipes from her youth and ones shared with her by her Vermont neighbors.

Marie brought a radio home from the Hayfords', where she boarded while attending People's Academy. It was a battery-operated radio, bringing news and entertainment as well as the world of consumerism to the farm. Sponsors were Brylcream, proclaiming that "a little dab'll do ya," and Prell Shampoo as popular culture became part of farm life.

Amos 'n' Andy was a daily fifteen-minute situation comedy that came over the airwaves. The two cohorts owned the Fresh Air Taxi Company. Their taxi had no windshield. It was up to the listeners to create the scenes in their minds. There was *The Life of Sherlock Holmes*, starring Basil Rathbone, and *The Life of Riley*, starring William Bendix. A neighbor charged one dollar per charge on a battery that ran the radio, getting energy from a windmill on his roof.

Gert said, "We had an old hired man up in Sterling. He worked for us for three dollars a week. His name was Jim. Mama was always reluctant to hand him his week's pay because as soon as he got his hands on it, he'd head down

to the village of Stowe, where he boozed it up quite heavily. One payday, he left in the horse and buggy for town and didn't come back. Then the horse and buggy came back up the road without him. Jim finally did make it home three days later, with a mighty hangover." Ouch.

The Walt Disney movie *Pinocchio* was released in theaters on February 7, 1940. The Bijou Theater in Morrisville featured it, and Mama soon picked up the expression "Jiminy Cricket!" The kids got a hoot out of that.

Two ministers residing up the hill near the Sterling Gorge had no church and no followers and came to the Sterling Valley farm one day looking for work from Mama and Papa.

Gert recalled, "Old Marvin and the younger one came down to the farm to make a dollar or two. One day Mama asked them, 'Why don't you stay for supper?'" They were quick to take up the offer. "Us kids were all seated around the table with Mama and Papa and the two ministers when one of the parsons lets go of some wind. Some *loud* wind. Well, us kids were tryin' so hard to concentrate on keeping quiet and all, and then the minister said, '*Excuse* me.' Well if we didn't start to laugh! Mama wasn't too happy with us, but we couldn't help it."

The woman from across the field asked Gert to take care of their cow while her husband was in the hospital. Gert milked the cow once a day for three months. They paid her three dollars. She cried when they paid her, she was so overjoyed. Soon she was perusing the Sears and Roebuck catalogue and ordering a pair of roller skates. Gert said, "We roller-skated in the barn over the cows in the hay loft. Before we hayed, it would be clear."

THE LEPINE KIDS
GROW UP IN AN EVER-
CHANGING WORLD

*A life-long blessing for children is to fill them with warm memories of
times together. Happy memories become treasures in the heart.*
−Charlotte Davis Kasll

Democratic candidate Franklin Delano Roosevelt was elected president
on March 4, 1933. FDR was the thirty-second president of the United
States, serving from 1933 to 1945—the only president to serve more than
two terms. He defeated Republican incumbent president Herbert Hoover,
and although Vermont didn't help get him elected, he became well respected
in the state.

The world was at an all-time financial low, and "Hoovervilles" were
cropping up in many places in the country. As the Great Depression got
greater, the majority of the country was enamored of FDR's campaign song,
"Happy Days Are Here Again."

As part of the New Deal, FDR established the Civil Conservation Corps
(CCC), creating jobs for 3 million men and women throughout the United
States within the interim of his first one hundred days.

Vermont's state forester, Perry Merrill, working for the CCC, hired
hundreds of men in the Green Mountain State. In Lamoille County, Merrill
directed a good portion of his workers to cut the first ski trails on Mount
Mansfield in Stowe, and in 1934, the first rope-tow on Mount Mansfield
was up and running by the power of a Ford Model-T engine, a four-cylinder
engine of twenty-horsepower capacity, its top speed hitting forty-five miles
per hour.

Embracing Vermont

Local Vermont schoolboys made money selling handcrafted woodwork that they created in the woodworking shop at the high school that now houses the Stowe Free Library and the Helen Day Art Center. The school was in service until 1971, when a new high school was opened on Barrows Road, off Luce Hill Road (named in honor of Stowe's first settlers, the Luce family).

The Three Green Doors on the Mountain Road was the students' venue for selling woodworking. A local painter, Walton Blodgett, sold his paintings at the Three Green Doors as well and bartered them at the Green Mountain Inn for a good New England home-style meal. A collection of his work still hangs in the inn. Walton Blodgett paintings are also part of the Lepine Girls' art collection that hangs in the Mount Sterling farmhouse.

As always, Gert and Jeanette were ingenious buddies, always creating. Taking two wheels off a platform scale of Thaddeus Fairbank's design, they designed and built a scooter. Standing on it, they steered it down their long driveway, wind in their hair and laughter in their throats.

The Lepine kids loved to play baseball, too. They used a rubber ball. One summer day, the ball became lost in the high meadows at the farm. Where to get another ball? As always, if the Lepine kids needed something, they figured out how to make it. Andre took a tree limb and a knife and carved a wooden ball, and then Gert got up to bat, taking a good hard swing at the whirling orb. The crack of the bat on the ball sounded like a sure home run as she ran the bases. It whistled and whizzed and whirred.

Mama ran quickly out of the house. "Who broke the front window?"

Gert had tears in her eyes. She never wanted to upset Mama. She quit running the bases and ran up and hid in the stone backhouse, staying there quite a while until it got to be suppertime and her appetite got the best of her.

As usual for this time of day, Mama was in the kitchen preparing something tasty: sliced fresh tomatoes from the garden on home-baked bread, fresh greens and buttered corn on the cob, a baked ham, strawberries and cream. Gert went on into the house to face the music. "I'm very sorry, Mama. You know I didn't mean to." By then Mama had cooled off.

She said, "Well, it was an accident. Everybody makes mistakes. You must be pretty hungry by now. You can set the table." Gert promised she would earn the money needed to replace the window.

"And you probably want to get another rubber ball." Mama had taken the wooden ball away from her kids for good. That was her way of disciplining. She used logic, not pain. Good food made by Mama was always a fine leveler. The world would go on in peace.

Mama had a wooden barrel butter churn that she turned with a crank. Cream thickened into butter. She just had to keep the temperature high enough and the churning needed to be done correctly. She was wise in this way, as in many other ways. She kept aside enough butter and cream for the house—for baking, cooking and, of course, milk for the family to drink. Skim milk was fed to the pigs.

The kids picked fiddleheads, chanterelles and leeks in the woods in summer. Mama sautéed the chanterelles and fiddleheads in butter. The leeks she used in soups.

Leaves began to turn color. Stick season followed autumn when leaves fell from the deciduous trees and the trees seemed to be dressed in bare sticks. Snow spit from the sky, and there was a cold nip in the air. It was Thanksgiving. Jeanette shot a wild turkey, and the girls dressed it.

Winter brought snowstorms. Wild winds whipped white drifts onto evergreens. Snow rollers pulled by Clydesdales smoothed the roads and bridges. Gert and Jeanette made a bob sleigh with tin runners. Hopping on it, they slid down the long driveway, where they had steered their homemade scooter that past summer.

Sunday Mass was celebrated in a Roman Catholic mission established in 1900 in the basement of the Ackley Memorial building on Main Street in the village of Stowe, next door to the town prison.

Stowe Hardware opened its doors in 1829. The little rise in the road outside the store was called Tin Shop Hill. Folks bought their tin products there, made to order, like stovepipes and grain shovels.

Another store on Main Street was owned by George W. Buzzell. George ran an undertaking business in the back of the store. He sold it to the Stafford family. The Staffords moved this business "upstreet," funeral parlor and all. In later years, it became a fun place to shop for little cuckoo clocks, knickknacks, greeting cards and perfumes. It had a full-fledged pharmacy.

Frank and Anne Lackey opened Lackey's on Main Street where the original Stafford shop was, after Stafford bought the place from Mr. Buzzell. Anne opened an art shop, and there was a barbershop, too, with an old-fashioned shop fixture twirling in red, white and blue. Their house was attached and still is.

Lackey's was and is that kind of store you may have dreamed about. You can find fireballs, cheap sunglasses, art supplies, comic books and Coca-Cola kept ice cold in an antique cooler, Frank Lackey's pride and joy. He carried the *New York Times* and sold gummy bears and postcards of local scenery, not

to mention memorabilia from days gone by collected here and there and exhibited around the store. "Not for sale, of course," he said.

Frank said, "Every kid likes to pick out their own Tootsie Roll Pop here, and every boy remembers his first haircut at the barbershop." Tootsie Roll Pops made their debut in 1932. The featured flavors were cherry, grape, orange, raspberry and strawberry. Every kid had his or her own favorite. Frank said, "When I realized I was selling Tootsie Roll Pops to the grandchildren of my original sucker consumers, I decided it was time to retire." Frank is still active in town, enjoying his walks to the post office in the village, "down the road a piece" from the home he's still sharing with his lovely wife, Anne. They love to go motoring over the countryside, frequenting the back roads up in Sterling Valley.

On winter Sunday mornings, Mama heated rocks on the wood stove, setting them in the horse-drawn sleigh. Her children's feet were kept toasty warm for the ride through snowy meadows as she made her way down to church on Main Street in Stowe in the Ackley Memorial building, giving the horse a touch of whip when it needed one.

The Union Bank had an office inside the building, as did the U.S. Postal Service and the Stowe Free Library. There was and is a theater upstairs. Movies were shown on a screen, and children were admitted for free. Pianist Etta Shackett accompanied silent movies with piano music. So it was a cultural center as well as a jail and a church, constructed in honor of U.S. soldiers.

Five could fit in the sleigh. Whoever went to Mass was treated to a five-cent candy bar after Mass at Boardman's Café, where the Stowe Area Association is now.

Gert said, "I used to look for the weight to get the most for my money. It was so big. A five-cent chocolate bar could last all the way home."

"Please, Mama, it's my turn to go!" insisted Therese.

"And me too, Mama!" exclaimed little Lawrence.

Years later, Marie reminisced, "Maria von Trapp attended the Catholic Mission with her children, and the singing was grand."

THE WAR YEARS

O Earth! Art thou not weary of the graves? Dear, Patient Mother Earth,
upon thy breast How are they heaped for farthest south to west!
—Caroline Ripley Dorr

It was 1941. It had snowed hard in Sterling Valley—had all week. The earth was blanketed in white as Mama and the kids kept the stoves burning and the kerosene lamps clean and full. They went down to the barn in the dark of the afternoon to milk the cows.

Jim, the hired hand, was still in the farmhouse lacing up his boots, preparing to go "down the barn" and take care of his afternoon chores. He lingered, as he had a habit of doing. His favorite radio show was airing, *Jack Armstrong, The All American Boy*. He loved to speculate on Jack's exciting travels, for in some way Jim was still a little boy at heart. Gert said, "Jim would listen intently and then slap his knee with his hand when something exciting happened to Jack Armstrong."

Suddenly, there was an interruption created by a stern announcement over the airwaves, blanking out *Jack Armstrong*. "Ladies and gentlemen, we interrupt this broadcast to bring you live, President Franklin Delano Roosevelt."

"Ah, phooey," said Jim. "And they were just gettin' to the best part. Jack was gonna make somethin' happen. I jes' know it." And he'd slap his knee. He put on his heavy wool coat and cap and his work gloves. "I better git to the baaan anaways."

In his absentminded way, Jim left on the radio. As he closed the door behind him, the voice of President Roosevelt filled the farmhouse:

Mr. Vice President, Mr. Speaker, members of the Senate and the House of Representatives: yesterday, December 7ᵗʰ, 1941, a date which will live in infamy, the United States of America was suddenly and deliberately attacked by naval and air forces of the Empire of Japan. The United States was at peace with that nation and at the solicitation of Japan, was still in conversation with its government and its Emperor looking toward the maintenance of peace in the Pacific.

Indeed, one hour after Japanese air squadrons had commenced bombing on the American island of Oahu, the Japanese Ambassador to the United States and his colleague delivered to our Secretary of State a formal reply to a recent American message. And, while this reply stated that it seemed useless to continue the existing diplomatic negotiations, it contained no threat or hint of an armed attack.

It will be recorded that the distance of Hawaii from Japan makes it obvious that the attack was deliberately planned many days or even weeks ago. During the intervening time the Japanese Government has deliberately sought to deceive the United States by false statements and expressions of hope for continued peace.

The attack yesterday on the Hawaiian Islands has caused severe damage to American naval and military forces. I regret to tell you that very many American lives have been lost. In addition American ships have been reported torpedoed on the high seas between San Francisco and Honolulu.

Yesterday the Japanese Government also launched attack against Malaya. Last night Japanese forces attacked Hong Kong. Last night Japanese forces attacked Guam. Last night the Japanese attacked Wake Island. And this morning the Japanese attacked Midway Island.

Japan has therefore undertaken a surprise offensive extending throughout the Pacific area. The facts of yesterday and today speak for themselves. The people of the United States have already formed their opinions and well understand the implications to the very life and safety of our nation.

As Commander-in-Chief of the Army and Navy I have directed that all measures be taken for our defense, that always will as our whole nation remember the character of the onslaught against us. No matter how long it may take us to overcome this premeditated invasion, the American people, in their righteous might, will win through to absolute victory.

I believe that I interpret the will of the Congress and of the people when I assert that we will not only defend ourselves to the uttermost but will make it very certain that this form of treachery shall never again endanger us. Hostilities exist. There is no blinking at the fact that our people, our

territory and our interests are in grave danger. With confidence in our armed
forces, with the unbounding determination of our people, we will gain the
inevitable triumph. So help us God.
 I ask that the Congress declare that since the unprovoked and dastardly
attack by Japan on Sunday, December 7th, 1941, a state of war has existed
between the United States and the Japanese Empire.

A rush of cold air caught Jim's face with a sharp sting as he entered the
barn. The snow fell softly. All was quiet in Sterling Valley on December
7, 1941. Nature didn't know about the changes. But big, violent world
events were erupting like so much molten lava, taking on its own
uncontrollable journey.

While the Japanese attacked in the South Pacific, extermination camps
in Poland (such as Auschwitz-Birkenau, Belzec, Chełmno, Majdanek and
Sobibor) carried out the torturous murder of Jews and others. There are no
words for the horrors that occurred in those places. Altogether there were
more than 430 camp complexes. How could it be that more than 6 million
Jews were put to death there as life went on for Americans, who seemed to be
kept completely unaware of this genocide? Paris was occupied. And soon the
Germans flew over the Thames, attacking England—an empire over which
the sun had never set.

The rhythm of the falling snow created powdery drifts in the meadows.
In the barn, Mama and the Girls were milking. Jim's nose smarted. The
pungent aroma of silage filled the air. "Begin the Beguine," played by Artie
Shaw, came over the radio in the barn. The cozy building lit by the kerosene
lamps and the farmhouse up on the hill—warm as toast, where Mama's
bread was baking—made it seem as if all was right with the world.

The Lepines listened to FDR's Fireside Chats on the radio and read
about the war in the *News & Citizen*, Morrisville's newspaper. As did other
farm families in Vermont, they began to save scrap metal for the war effort.
The U.S. government used radiators to make airplanes, pots and pans and
toothpaste tubes. There was a strong sense of nationalism in Vermont and
throughout America. During what was called the big-band era, 70 million
enlisted U.S. men and women lost their lives overseas during World War II.

On February 19, 1941, the *News & Citizen* warned the public that
American legionaries, ages forty-five to sixty, should register with the U.S.
government for prospective service to the country. Local Lamoille County
citizens joined the army's Tenth Mountain Division in Fort Drum, New
York. These soldiers were taught to fight in mountain terrain. They often

needed to plot a course and travel on skis in the mountains of Italy, where Mussolini dictated the Italian masses, calling for fascism.

Fifty thousand of the men and women who served in World War II from the United States were Vermonters. Twelve thousand of those died serving their country in that war.

There was a new propaganda program being waged in the States. The icon "Rosie the Riveter" was created, persuading American women that it was their civic duty to go into the factories and airplane plants and take over the jobs left empty by enlisted American soldiers. On billboards across the land, Rosie wore a striped shirt with sleeves rolled up, flexing her biceps as she said, "We can do it."

Rosies were employed across the United States. Women realized that they could have well-paying careers outside the home, be educated and attend colleges and trade schools. They loved this liberation. It is interesting to note that in her own way, Imelda Lepine was already liberated. She was a businesswoman, earning her own money from her craft at creating beautiful things, growing foodstuffs and preserving and selling them. She emulated Rosie the Riveter in ways that set a lasting paradigm of the freedom and independence her daughters could and did achieve.

A handmade sign hung on the front of the general store building at Morristown Corners: "Give Salvage, Save the Country." Other posters were put up around the towns of Lamoille County—Uncle Sam pointing his index finger, saying, "Uncle Sam Wants *You*!"

Even though it was wartime and so much had changed, the annual fair was still held every August at the fairground in Morrisville where Hannaford's grocery store is now. There were livestock shows and gypsies (around whom mothers were warned to watch their children—there were rumors that the gypsies tried to steal children). As the tents went up at the fairground, the Lepine Girls collected scrap metal for the government drive.

The price of admission to the fair was one dime. Opening day arrived, and Papa hitched up the horse and buggy. Loaded up with the kids, the buggy rolled down Sterling Brook Road, up Stagecoach Road, past the Morristown Corner General Store and into the town of Morrisville to the *clip-clop* of the hooves. Papa stopped at Munson's grocery store on Main Street where Bournes is now, next to the restaurant the Bee's Knees. Mama stayed home.

Papa said to the grocer, "Give me all your overripe bananas." With a paper bag filled with the fruit, Papa got back into the buggy and passed out lunch. Lawrence liked them a bit *too* much. He ate a bunch. The family arrived at the fairgrounds, where a big crowd had gathered. People were

there from all over Lamoille County. Lawrence complained to Papa of a tummy ache. His face got pale. Papa took him around under the bleachers. Up came the bananas. "No cotton candy for you," Papa said.

The kids looked at the betting games, remembering the rules and the methods for setting up their own games for when they got back home on the farm. Gert refused to go on the rides. "No Ferris wheel for me!" she said. Her favorite height at the time was on the back of her horse at the top of a great meadow. She has never been up in a plane. Signs were posted throughout the fairgrounds: "No spitting allowed!"

Gert said, "Tuberculosis was spreading like the blazes in Vermont. A local man, Bill Bartlett, got up on the podium at the fair, telling the crowd about his experience with TB."

Bill said, "I came down with the dreaded disease and took my own cure. Headed up to my mountain cabin in Stowe and took in as much of the clean, fresh air as I could. I'm a cured man, today." The crowd applauded.

On May 4, 1942, in Lamoille County, sugar rationing began as a war effort. The very next week, gas rationing was enforced. The kids were in high school, boarding "down street." This separated the kids from the home they loved. They stayed at different houses while attending high school at People's Academy. The school was originally called the Poor People's Academy, as wealthy people in town sent their children off to Burlington to be educated. On weekends, the Lepine children came back home to the farm in Sterling.

Gert said to Jeanette, "I hate every minute of this boarding 'down street.' People's Academy was many miles from the farm."

"Papa looked for a farm to buy, closer to People's Academy, where we were going to school. It was 1943 when he found an old run-down place in Mud City, a hamlet in Morristown named as such in 1888. The farm was set on 140 acres, with a collapsing barn and a shell of a house. The price was $1,200," Jeanette said. "Papa told Francis Clark that he'd love to buy the place. Francis and Papa held an auction up at the Sterling farm, liquidating the value that had accrued over the past eight years. Papa bought the team of horses. Frances and Papa split on the pigs, and at the end of the auction, Papa made $900 on the deal, as well as a few sheep, three pigs and a couple cows."

Gert said, "During these years in Sterling Valley, Papa got into pig farming. He had thirty sows, and he sold piglets at ten dollars apiece. He was the town garbage man, feeding his pigs from the compost he picked up, and folks came in from all over Vermont to buy his piglets." Mama pickled the pigs' feet and fed her family with pork.

Gert said, "It was here, with Papa's hard work, that my family had the ability to buy Mount Sterling Farm. With that and some money he had saved from his garbage route, Papa bought Mount Sterling Farm." Together the Lepines walked the animals through the hills and dales from Sterling Valley to Mud City and their new home, Mount Sterling Farm.

Gert said, "We built the original barn. We cut all the lumber with a cross-cut saw. Pulled the wood with horses to the mill. It cost us eight dollars per thousand to have your logs sawed. We had seventy acres of woods."

CHANGING TIMES

I think that the best thing we can do for our children is to allow them to do things for themselves, allow them to be strong, allow them to experience life on their own terms, allow them to take the subway…let them be better people, let them believe more in themselves.
—C. Joy Bell

An era had come to an end, and a new one had begun. The Lepines spent eight years in Sterling, a place in time for them that they recalled as "the best years of our lives."

The Lepines cleared the land working with the help of soil conservationists. Gert said, "Three other farms in Mud City went up for sale. Papa bought them and the farm grew to 640 acres." She added, "Lawrence was a big part of creating Mount Sterling Farm. Together we cleared 130 acres. We cleared 10 acres per year, seeding the land with Levino clover and Timothy."

In winter, Gert and Jeanette were skiing Mount Mansfield, enjoying the beauty and fun of the sport. Day ski passes on the mountain were fifty cents. Now, a one-day ticket can cost up to $92 and a week's worth up to $546. They cross-country skied through the woods and meadows for miles, as far as a place called the Besser Farm, a classic farmhouse with a porch facing the Worcester Range on Stagecoach Road. The farm is still there, painted yellow, rocking chairs on the porch and a big old barn and sugar shack on the property.

Marie was the first to graduate from People's Academy. She and her school friend Evelyn Allen decided to find independence. Mama and Papa took them to the train station, where the two young women boarded a passenger

train to Washington, D.C. It was a wooden-bodied coach. With a *chug-a-chug-a-chug* and an "all aboard!" they headed south to a different world.

Marie recalled years later, "When I was in high school at People's Academy, recruiters came from the FBI to People's Academy. The boys were all going off to war, so they were recruiting us girls to go and work in Washington. They trained me in fingerprinting." She pointed to her fingers. "All these little swirls can be studied. Everyone's fingerprints are unique, of course."

It was a romantic time to be young. Life was simpler then. Slower. Marie and Evelyn found a place to live in a boardinghouse and went to work. Marie said, "The war raged on in Europe and the South Pacific. We were losing so many of our young men and women to the fight. But there was an overall confidence that FDR would see it through to an end soon."

Back in Vermont, Therese earned her secretarial diploma and got a job working for the Vermont State Tax Department, secretary to State Treasurer George Amidon. Then she decided to join the United States Navy and serve her country. She was assigned to the navy's Scofield Barracks in Hawaii, working in decoding as a communication specialist. Years later, Jeanette recalled, "Gert and I kept asking Therese to fill us in on the things she decoded. Ya know, this was years later, when the war was over. But no. Therese never divulged one *single* secret!"

Therese returned to Vermont and applied for a job as Senator George Aiken's agriculture secretary in Washington, D.C. Therese got the job, working for Aiken for several years. Aiken had served as Vermont's lieutenant governor from 1934 to 1936 and as governor from 1937 to 1941 and became a senator on November 5, 1941, as a result of Ernest W. Gibson's death. He was reelected in 1944, 1950 and 1956. He believed that the idea of buying on credit was taking the country by the wallet. Aiken didn't buy it and encouraged Vermonters not to buy it either. Aiken wouldn't sell out to big government when it tried to convince him how much happier Vermonters would be with more "things." Aiken defended the general consensus of Vermont farmers that money couldn't buy the freedom they treasured or give them the fresh Vermont air they breathed. One couldn't put a price on living independent lives on God's earth—the way Vermonters chose to live.

Things wouldn't always be that way in Vermont. Some farmers sold out in time, due to forces out of their control with manipulation of milk prices by the government, the cost of feed and such. Some couldn't afford to farm anymore.

The Green Mountain Inn, Main Street, Stowe, Vermont.

Aiken backed Vermonters in his votes in Washington when he became Vermont's senator from 1941 to 1975. He was so popular in Vermont that he spent a mere $17.09 on his final election. Therese worked for Senator Aiken for twenty-one years. When he retired, she came back to Vermont and worked for two more years in Burlington for Vermont senator Robert Stafford. Stafford was Vermont's seventy-first governor and a United States representative before he became a Republican senator, known for his moderately liberal views. He was an ardent environmentalist and supporter of the gay rights movement in Vermont, and the law passed in Vermont in 2000 that legalized civil unions between two people of the same sex.

Marie and Therese, two Vermont farm women and immigrants to the United States from Ham-Sud, Quebec, held high-ranking jobs in Washington, D.C. They both remembered clearly April 12, 1945. Marie was in Washington, D.C., the day President Franklin Delano Roosevelt passed away from a massive hemorrhage while having his portrait painted in the company of his lover, Lucy Mercer. Of course, only a few, including Eleanor Roosevelt, were privy to who was at his deathbed until the 1960s, when this information was revealed to the public.

Marie said, "I remember the funeral march down Pennsylvania Avenue. The throngs of mourners paying their respects as the carriage carried the

president's body back to the White House." The funeral was held in the east room of the Executive Mansion. Marie said, "The crowds were massive when the carriage began the journey away from the White House to the train station, where the president's body was boarded to be interred in Hyde Park, New York, at his family's home."

The late FDR and Eleanor Roosevelt's four sons were on active duty in the U.S. Navy in the South Pacific. Mrs. Roosevelt wired the following message to her boys: "Your father did his job to the end as he would want you to. Bless you all and all our love. Mother." Eleanor kept her grace in public, even after she learned that it was her daughter, Anna Roosevelt, who had arranged for FDR to spend what would be his last day in the company of Lucy Mercer. FDR, Lucy and Anna had lunch together at the family home in Warm Springs on that day, before FDR died in bed, taking a rest while having his portrait painted.

Gert was on a class trip in Burlington the day FDR died. She said that *Our Hearts Were Young and Gay* was on the marquee at the theater. This charming story takes place in 1923, before the onslaught of the Crash of 1929 and the agony of World War II, when it was quite unusual for two young American women to board a cruise ship for Europe unescorted. How quickly the world changed.

Marie was in Washington when on August 6, 1945, under the direction of President Truman, "Little Boy" (code name for the atomic bomb) was dropped on Hiroshima, Japan, from the *Enola Gay*, killing more than 90,000 people—possibly as many as 160,000. Strange variable in the statistics. Flash burns and melted eyeballs. Hell on earth.

On August 15, 1945, dropped from the B-29 *Bockscar*, an atomic bomb, codenamed "Fat Man," exploded over Nagasaki, Japan, with a yield of twenty-one kilotons of TNT. An innocence was lost among the Lepine family and with them every family in Vermont and around the world who heard the news. Farm life…city life—no one was safe from the atom bomb.

On September 2, 1945, Japan surrendered to the Allied powers. World War II came to an end and the boys came marching home. When Marie returned to Vermont, after having had enough of the city life, she worked at the Lodge at Smuggler's Notch in bookkeeping. She met Othmar Wallingar, a handsome young Austrian who played piano there. Marie and Othmar traveled to Pennsylvania from Vermont with a friend in the music world and married. In pictures of Marie as a bride, she appears like an Austrian princess in an exotic gown and veil.

Jeanette said years later, "Mama would have loved to be at the wedding. When you're working a farm, you're committed to it 365 days of the year."

At the age of eighty-eight, Marie is a sweet, feminine, diminutive woman. She wears her hair in a ponytail like a young girl. "When we came back to Vermont, after our wedding, Othmar learned how to rebuild pianos from a local man named Dr. Lichelager. We rented the little place next to Stebbin's Market, and I opened a flower shop there. Then I got a job at the Trapp Family Lodge on Luce Hill at the front desk. I was Maria's confidante," she recalled recently, as she sat in the farmhouse in Mud City. "She would invite me into her room, where we discussed things. I remember one conversation we had, in particular. She had been very upset. 'I haven't any privacy,' she told me, because the guests always wanted to 'meet the woman that was *the* Maria in *The Sound of Music*.' Well, soon after that, Maria told me, she was changing all that. From that day on, she would allot only one day a week to meet with the guests. I liked Maria very much. She was a very strong-willed woman." Maria wore a three-hundred-year-old cross on a necklace, as well as Austrian dirndls and kerchiefs on her head. She was an athletic woman who loved to swim and enjoy the outdoors.

Marie said, "My husband Othmar and I went wandering across the country. We became restaurateurs, opening a German/Austrian restaurant in Colorado. We never had any children." Othmar passed away, and when he did, Marie returned back to the farmhouse to live with the other Lepine Girls.

Gert graduated from Johnson State College in 1949 and was hired for a teaching job in Bakersfield, Vermont, located in the northwestern part of the state. She boarded in Bakersfield during the week and on weekends drove back home to Mount Sterling Farm. She said, "My salary was twenty-eight dollars a week. I received a paycheck every two weeks for sixty-six dollars, paying eighteen dollars room and board for a five-day school week, leaving ten dollars a week for expenses—gas money and such."

Gert loved to read and still does. She said, "I enjoy Cormac McCarthy, Steinbeck and Hemingway, but my favorite author is Willa Cather and my favorite novel is hers: *My Antonia*. I've read it twice." Here's an excerpt from *My Antonia*, written in 1918: "When I strike the open plains, something happens. I breathe differently. That love of great spaces of rolling country like the sea—it's the great passion of my life."

To know Gert Lepine is to see a resemblance between her, Antonia and Cather. All three were tomboys, children of immigrant farmers. Cather's masterpiece is set in the wide-open landscape of Nebraska. Like her protagonist, Antonia, Cather was brave-spirited and danced to her own

A photograph of Therese taken during her years in the navy, World War II era.

music, as does Gert. When a teaching position opened up in a one-room schoolhouse in Stowe Hollow in 1952, Gert applied for the job and was hired. The job was a ten-minute ride by car from Mount Sterling Farm to school. She moved back home to the farm. At 6:00 a.m., she was down in the barn, doing chores and milking cows, then she taught school all day, making it back in time for the afternoon milking.

March arrived. Monday morning came, a day Gert hated. She didn't want to leave the farm. She'd been out in the sugar bush with Lawrence tapping that weekend. "I can remember so well that warmth of spring." She said, "At school, my recesses had been getting longer and longer, and when teaching my class one particular Monday after sugaring, all of a sudden, I looked out of the open window at the beautiful spring day. I could smell the spring. I could feel it in my bones, and then I knew for sure where I *had* to be and it wasn't where I was."

Her mind wandered to the activities of the weekend—being out in the fresh, pine-scented air in the woods, collecting sap in tin buckets. She felt like singing and she couldn't. She felt like swearing and she couldn't, and so

Therese with President Lyndon Baines Johnson, Washington, D.C., while she was working as a secretary for Vermont senator George Aiken.

she said to herself, "What am I doing in *here*? I can't *swear* and I can't *sing*. I'm going *home*, for *good*!" Farm life was a "calling." She felt like a wild bird in a small cage, yearning for open skies. The walls were closing in on her, and then the bell rang for her for the last time. When she got home from school, she went to the barn where Papa was.

"Hi, Papa," she said.

"Hi, Gert. How was school today?"

She explained the way she felt and told him that her heart belonged at home on the farm. She asked him what he thought about her becoming a full-time farmer and starting her own herd of cows.

"It's fine with me, Gert," he replied. With great relief and a happy heart, she walked up the hill to the farmhouse and made a phone call to the school superintendent.

She said to him, "I won't be coming back to school. You see, I quit." Imagine the shock he felt at having one of his female teachers exhibiting such raw independence.

He said, "What do you mean you're quitting? You've only got another few months to go and school will be out for the summer."

"I'm aware of that, but something happened to me today in the schoolroom, and I've made up my mind. I've got to get out."

"This is going to be the end of your teaching career. I'll see to that, Miss Lepine. You will *never* have a chance for another teaching position in the entire state of Vermont! Mark my words."

"Well, you mark mine. I'm through with teaching forever. I'm going to be a farmer."

"What are you going to do on the farm? Bookkeeping?"

"No. I don't like bookkeeping. Listen here. Look me up in twenty years, and you'll see what I've done."

Papa offered her a salary in return for the work she'd put in at the farm and would be doing in the future. She said, "I don't *care* about the money!"

Papa said, "I've got to pay you something. Besides, I have put aside $1,000 over the years."

"Okay, Papa, then why don't we take the $1,000 and take a ride up to Brigham Farm and pick out some good Jersey heifers?"

"Sounds good to me, Gert."

"Well, let's go then!"

As Gert once said, "The sap was running and so was I."

It was 1951, and the economy was finally good again. It was a warm spring afternoon, and Sterling Mountain had a rosy glow. It is a mountain of might and grace, with a thirty-acre pond at its summit. It is known to be shaped like a four-leaf clover. And in the summer, for those lucky enough to hike to the top, they feast their eyes on the pond with waterlilies abloom.

There was a wonderful energy in the air. Gert could hardly contain her excitement. Papa, Gert and Lawrence got into Gert's truck, and with $1,000 in Papa's jeans, they headed north to St. Albans to the Brigham Farm. Mr. Brigham had been the state's commissioner of agriculture from 1919 until 1924.

Together, Papa, Gert and Lawrence picked out some very fine-looking Jersey heifers. Gert said, "Brigham had the top herd in the country. Brigham's herdsman, Lacass, delivered the cows to Mount Sterling Farm for us. He said to me, 'I'm giving you a few years, and you'll be selling heifers that are worth a lot more than these.'"

The most famous Jersey cow is Elsie Borden. Jerseys are a comparatively small breed of genial animals and were first bred on the Island of Jersey, one of England's channel islands about fourteen miles off the coast of France. Her Majesty Queen Elizabeth of the house of Windsor owns one of the oldest breeds of Jerseys. They are known for their high butterfat content, low maintenance due to lower body weight than other breeds and high fertility rates.

With these five cows that cost $200 apiece, Gert, Lawrence, Mama and Papa began their own registered breed, the Mount Sterling Jerseys. They named her cows. There was Veronica, Sapphire and Daisy, Typhoon and Mighty Might. They bred them with a bull in the early years.

Gert said, "I had one bull, he was Princess's son. He attacked me. Knocked me down against a fence. Rolled me." Later on, she purchased frozen semen for artificial insemination through the American Jersey Cattle Association. She said, "It's the best breeding in the world." In 1938, Rutgers University in New Jersey created the premier commercial artificial insemination organization in the United States.

Gert said, "This process permits a farmer to reproduce quality characteristics such as milk quality and fertility and to breed out undesirable traits." When a cow is in estrus, the semen is thawed from its frozen state. The cow is fertilized. Gert said, "I had a breeder who took care of the job."

Gert's Mount Sterling Jerseys were ranked in the top percentile for milk production in the state of Vermont and top ten in the United States. Gert was thrilled with these beautiful animals and took pride in them, giving them the best of care.

Andre left the farm to attend university and became an agriculture teacher in a high school in New York. Gert had been partners with Lawrence after Papa died in 1957, and then she bought him out, becoming the sole owner of Mount Sterling Farm. Lawrence left the farm and went out to California to start a hog ranch.

Jeanette graduated from high school and was working as a secretary for Francis Clark. One day, while picking potatoes, an airplane flew over her head. These were the days of luxury airliners, and it piqued her interest. Jeanette said to herself, "I want to be up there, flying in one of those airplanes. I'm going to become an airline stewardess!"

Gert said, "I think she really wanted to be a pilot!"

Jeanette expressed her interest to Francis Clark. He asked her, "Where do you want to fly, Jeanette?"

She said, "You know. All over the world."

"Then you should apply to an international airlines. Pan American would be a good choice."

Pan Am was initiated as charter service for well-to-do bluebloods, savvy businessmen and movie stars. It was financed in part by Cornelius Vanderbilt and Whitney and William A. Rockefeller. Pan Am was the first of its kind in the jet era to offer passenger aviation. Pan Am's pilots flew Boeing 747s

Jeanette as a Pan American World Airways stewardess posing with airline passenger Cesar Romero.

that could fly as many as 490 passengers by 1966. Their stewardesses were considered the most desirable of women—intelligent, polite and attractive.

Jeanette obtained the address of Pan American's corporate offices in New York City and drove her Oldsmobile down for an interview. A flat tire in Queens held her up briefly, and then it was on to New York City. She was bilingual and very attractive—a shoe-in. She went back to Mud City. A letter arrived in the mailbox from Pan American World Airways, addressed to Miss Jeanette Lepine. She opened it. The letter informed her that she was under consideration for a job as an airline stewardess for the company, and it called her back to New York for another interview. She said, "Altogether I had four interviews, then I was hired."

These were the days of luxury planes, like Boeing Stratocruisers. The planes had two floors and elegant lounges. There was a bar in every plane.

In her striking blue uniform and cap and nylon stockings, she began her international career. She said, "I never wore a girdle, even though we were supposed to. They never knew the difference." Her route was Europe, Asia,

Jeanette modeling
as a Pan American
stewardess with
Finnish furs in
London.

Hong Kong and Thailand. She enjoyed lengthy layovers in foreign ports, skied in Austria and enjoyed the beauty of the City of Lights, gay "Par-ee." Among the passengers on her flights were Robert F. Kennedy and the young Julie Andrews before her days as Maria von Trapp in *The Sound of Music*. Miss Andrews came to Broadway in 1954 with *The Boyfriend*, and in 1955, she starred as Eliza Doolittle in *My Fair Lady*. Jeanette said, "Julie Andrews was very young and very sweet. All my customers were nice, and I respected their privacy. Famous or not, I treated them all the same."

Being the amiable type, Jeanette made friends in her travels. She said, "I was in Paris on a layover, and a friend back home in Vermont had asked me to pick up some French perfume for her while I was there. Well, I meant to pack it, but when I got back to the farm, it wasn't in my bags. Well, a couple weeks went by, then a package came for me in the mail. It was from a wonderful French couple I met over in France. They had found the perfume and some of my identification was with it. They mailed it home to me. After

that, whenever I was in Paris, I would go visit them at their apartment. They were simple people. Very nice."

Full-course meals were served on all the flights. On flights to Hong Kong, barbecued duck, chicken or pork, steamed rice, Chinese soup and green tea were served.

Jeanette said, "There was time between flights, and I always went back to the farm." As time went on, the glamour faded and flying became a common affair.

The question has been asked, 'How ya gonna keep her down on the farm after she's seen Paris?" But Jeanette looked forward to going home to the family farm. She said, "There was a farm up the road for sale from Mount Sterling Farm. I was buying it on time. I figured when I paid it off, I would retire from the airlines and come back to Vermont for good."

When flying became a different ballgame—smaller planes and more passengers—she felt that the stewardesses were mistreated and decided she had a choice to make about her life. She has said more than once, "I could either take shit or shovel it." She opted for the latter choice and paid off the farm "just up the road a piece" from family headquarters, Gert's Mount Sterling Farm. Her stewardess days were a thing of the past. She bought her farm from a man named Clyde (hence the name) and let him live there for the rest of his life, and she moved in to Mount Sterling Farm with Gert.

THE LEPINE WOMEN'S FARM

The Stowe Reporter *asked me in an interview, "If there was just one person you could have dinner with, who would it be?" I said, without hesitation, "Jeanette Lepine!"*
—Bambi Freeman, a seasoned shepherdess and
1980 "Farmer of the Year" in Sterling Valley

Jeanette was collecting and selling antiques, as well as farming back in Mud City. She created the Mud City Antique Market at her farm in Mud City.

She said, "I had it for about ten years. People traveled from all over to Mud City to attend the market, enjoying looking at old treasures while picnicking on homemade food. I had over forty-five antique dealers at the market at one time. Sundays from Memorial Day until Columbus Day. People were just craving antiques back then, but now I can't find any. I used to advertise in the *Maine Antique Digest*, and I bought out the remains of $12,000 worth of antiques in a shop in Jeffersonville."

Gert said, "We served refreshments that the people loved."

Jeanette said, "I had a little garage at my farm where the food was served. Marlene, a friend of ours, ran the food booth. She served hot dogs and hamburgers and cocoa. And one of the girl tenants that was renting from me baked some fancy cuisine. Cookies and squares. It was great fun. Some people came for just the *food*."

Mama loved Jeanette's antique markets. She and Jeanette caned antique chairs and had a good time doing it. Therese bought a farm up the road

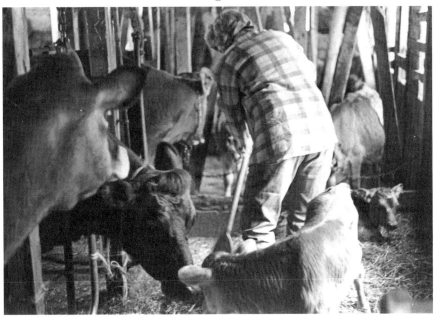

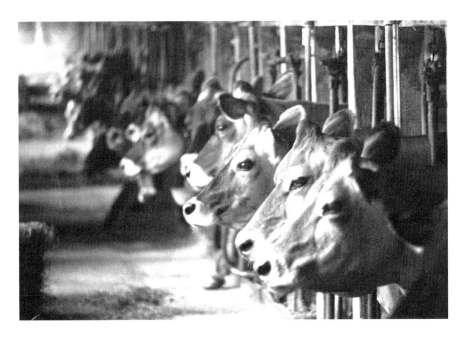

This page: The Mount Sterling Jerseys in the barn, Mount Sterling Farm.

Jeanette's silhouette as she comes into the barn at Mount Sterling Farm for the afternoon milking.

Gert haying out in the meadow at Mount Sterling Farm on her tractor.

from the family farm when she retired from her job in Burlington and joined Gert, Jeanette and Mama. This family of women were all farmers again at the homestead. Therese would go home to her own farm up the road at night. At her farm, Jeanette let Clyde, the man she bought it from, have a lifetime lease. She also turned her chicken coop there into a miniature cottage and rented that out. In time, Gert and Jeanette bought at auction the general store building at Morristown Corners. She rented out the store, and she and Gert turned the back of the building into an art gallery. They named it the Jacob Walker Art Gallery, after Morristown's first settler. The gallery was a quaint venue for Vermont artists and was run as a cooperative.

Jeanette said, "It was the first art gallery in the area." As time went by, a family approached them about transforming the building into the Green Top Market.

Gert said, "We still own the building, hold a mortgage."

The market is an elegant, upscale place. Carol and Michael Hamilton are the owners. Carol said, "We carry all local meats. We're almost 100 percent local, and that's what we're all about." It features cheeses from Sage Farm Goat Dairy located on West Hill in Stowe. As the French do, the cheese makers name their cheeses for the region. They make Sterling and Madonna goat cheese, named for the surrounding mountains, and a great chevre.

But let's go back again, before so many changes took place. It was just the Girls, now all back in Mud City on Mount Sterling Farm, farming together at last. It was finally Mama, Therese, Jeanette and Gert and their *freedom*. Nobody to tell them what to do or how to do it—just as Jeanette said when the teacher tried to teach them to throw a ball that they could throw better. Well, they farmed better than anyone who ever wanted to advise them; no one could tell them how to live their God-given lives.

As sole owner of the beautiful Mount Sterling Farm, Gert said, "We plowed the fields, planted vegetable gardens, cut our hay and baled it as my breed of cows, Mount Sterling Jerseys, grew in number." Jeanette was the veterinarian. Gert maintained the tractors and other machinery and loved to cut wood.

Gert said, "Mama was a great gardener. Always was. So, just like it was as we were kids, she was harvesting vegetables with us. We put in sixteen-hour workdays, and by 1991, they were milking sixty-five cows utilizing four hundred tons of their hay a year."

It was a women's farm now. There were no males at all, not even a bull. Mama and Therese were in the family's two-story farmhouse's country kitchen, setting the table for breakfast one morning in winter. Therese picked up a pitcher of fresh raw milk, pouring a glass, and then fed the wood furnace in the basement.

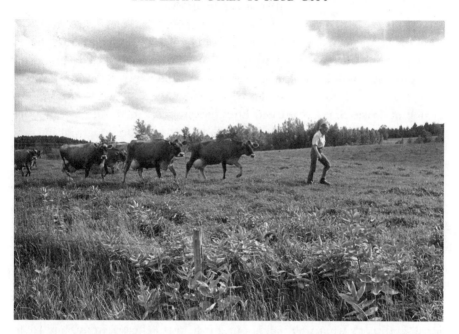

Jeanette bringing in the Jerseys for their afternoon milking at Mount Sterling Farm.

The Mount Sterling Jerseys crossing on the Mud City Loop, headed for the pasture as the school bus waits.

Mama Lepine caning a chair.

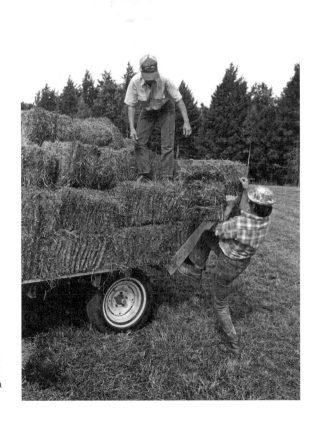

Jeanette and Gert haying in a pasture at Mount Sterling Farm. Gert is throwing up a bale to Jeanette.

There's a sizable vent on the kitchen floor where the heat comes up from the basement. Mama meant it when they moved into this farmhouse that she never would be cold again. Even the barn was warm and friendly. Gert was the fire tender. A clock on the wall that never sprung forward and never fell back read 6:30 a.m. "We were always on Daylight Savings Time," said Gert. "That way we didn't disrupt the cows' milking schedule."

When he heard a book was being written about them, a local, Lloyd Shackett, born in the Morristown Corner area of town said recently while he was doing some repair work on my Subaru Outback, "I remember years ago when the priest at Holy Cross Catholic Church in Morrisville changed the time of the afternoon Mass to fit their milking schedule." Now that's Vermont for you.

Anyway, Mama finally remembered her prayers, took her bread from the oven to cool and scooped fruit preserves she'd put up into a bowl. Performing her tasks, she peacefully prayed the rosary in French. "Je vous salue, Marie, plein de grace. Vous ete beine entre tout les femmes, et Jesus, le fruit de yos entrailles, est beni. Saint Marie, Mere de Dieu, preix pour nour pavres pecheurs maintentant et a l'heure de notre mort. Amsi sort tie." How often she had turned to pray in times of thanksgiving and in times of great travail ever since the days at Marguerite D'Youville's convent of the Sisters of Charity.

Gert recalled, "One time, I remember, Mama, of course, was getting older. Well, she knelt right down here on the dining room floor to say her prayers and was silent. 'I forgot my prayers!' she said." Well, the lucky ones among us age long enough to sometimes forget our prayers. Maybe by then God is saying them for us.

There was this eternal chain that developed over the years of women teaching women and helping one another find their road to solace and independence with a true sense of worth. This story is proof of historically strong women who gave the feminine a *sacred* voice.

In the evening on Sunday nights, the Girls turned again to the radio, as they had back in the old days. But now they listened to the tales of Garrison Keillor. And now they had a television set. The five o'clock evening news on WCAX's channel 3, Vermont's number-one station, became a ritual for the Lepines and in many homes throughout Vermont. Sharon Myers is our weather girl. Blond and cheerful, Sharon has guided us through blustery blizzards, floods, droughts, birdwatching and the thinning of our perennials. She's always there and always has a smile for the viewer.

Oil paintings by artists, both famous and still green, hung on the walls. The rugs on the floor were Mama's creations. The family beagle lay curled up near the heating vent, with Therese's cat curled up next to him.

This page: Jeanette and Gert building a log cabin in Sterling Valley.

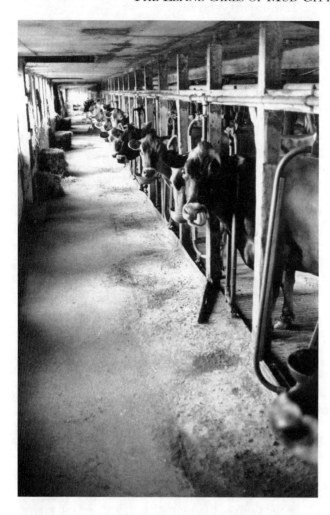

Inside the
immaculately kept
Mount Sterling barn.

A little before seven o'clock in the morning, Mama laced up her leather work boots. Dressed in blue jeans with a rope for a belt, she bundled up in her hat, coat and leather gloves. She walked down the hill through the falling snow, as she had done for many winters at Mount Sterling Farm in Mud City. What were her memories like? Did she reminisce about the old days with Maurice? Of the blessed days when the children were young in Sterling Valley with all their sense of adventure and good times and learning how to survive and thrive?

She still wore her beautiful French twist. It was snow white now. She looked up at the summit of Sterling Mountain, which sheltered the farm like a mother's embrace, and then Imelda opened a big wooden door to the barn and softly smiled at daughters Gert and Jeanette. A painting of Paris hung

cockeyed on the wall, as it had for many years. The Girls had been milking their Jerseys since five o'clock. Imelda got her water ready, content to be working in the barn with her daughters. The beautifully kept barn to these farm girls was like a sleek schooner to sailors at sea.

Although the wind was whipping outdoors, as snow drifted and swirled, sweet-tempered Jerseys contentedly listened to Ella Fitzgerald's voice in song, a morning feature on WDEV, the Waterbury radio station. Ella sang "Love and Kisses" and "You Have to Swing." Dawn was breaking.

Jeanette said, "The disc jockey stopped by late one night. He asked me if there was any special music Gert and I liked to milk to. I told him, 'Give us lots of Ella Fitzgerald. The cows love her.'" The Girls milked twice a day, working on opposite sides of the barn, milking from one end of the barn to the other. Dressed in their favorite clothes—blue jeans, work boots and hats, warm woolens in winter and cotton shirts in summer—they milked 365 days a year, no exceptions. Their chores alone took nine hours a day. Gert hadn't missed a day of work since 1952, when she put away the teacher's manual and sat down on a milk stool as a daily ritual.

Gert said, "Jeanette and I milk. We handle two units apiece. And Therese, she's the third man. She's supposed to pick up after us, keep the cows scraped down and all that, and she checks the cows, if they need checking. When it comes to cleaning, Therese's work is the platforms. She does this in the morning. Then she cleans the calves and does odd chores."

Jeanette said, "There are easier ways and faster ways than to milk four cows at a time, into separate buckets. But it's the only way you can tell how much milk each cow is giving. We know each individual udder. That's why we each milk one side." She expressed the idea that women are better milkers—gentler than men. "We're not so apt to whack a cow if she kicks." Worldwide (like in Russia and England) it is women who do the milking.

Charlie L'Esperance, a fertilizer salesman, stopped by the farm one day. He pulled his truck up to the barn and got out, sizing things up. He said, "I kept looking for the man of the house. You know, the guy that was in charge." Then Gert came out of the barn and asked him what he wanted.

"I'd like to meet the man of the house, you know, the boss."

Gert said, "You're lookin' at the boss. There is no man of the house. This farm's run entirely by women."

When the Girls began farming full time, Gert in 1952 and Jeanette in 1961, the majority of women didn't work outside of the house, and for those who did, the choices were very limited. Men were doctors and women were nurses. Men were lawyers and women were secretaries. Men were judges and women were stenographers. Men were farmers and women were farmers' wives.

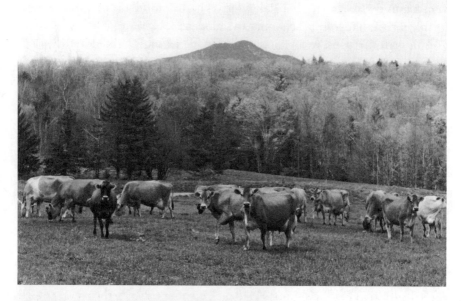

Above: Mount Sterling Jerseys.

Left: Mama "doin' up the dishes" in the dairy barn at Mount Sterling Farm.

Embracing Vermont

On the radio program *Living on Earth* the day of the Lepines' Jersey auction at Mount Sterling Farm, Gert said, "Funny thing is, I wanted to farm, but I don't know, it was a funny concept. People didn't think that, you know, I mean every farm wife spends her life farming. But for a single person to do that for a lifetime, I've had you know, back when I started handling fertilizer or something, some of these truck drivers would, you know, kind of laugh at me, because I was doing heavy manual work. I never made a distinction that you know, what was the difference? Why shouldn't I farm if I wanted to? I wanted my freedom, my independence, and you know that's what people don't understand. Talk about freedom and you'll...there's nobody more committed than we are. We're married to these cows, actually, you know, I mean it's a 365-day-a-year operation. And I really honestly don't think I've ever missed a day of milking in my forty—how many years have I been here? Since '52? What does that make, forty...forty-four years."

Jeanette and Gert worked in the barn and in the fields. Gert said, "I'm the herdsman." In the 1980s, Jeanette and Gert, along with a partner, bought the Sterling Valley farm and the land they had loved and lived on as children and had spent a good part of their childhood—a total of 150 acres. They rented out the chalet and the property to a man named Joe and his family. With his sister, Joe measured a line where he would build a sugarhouse. His family and friends helped, and Joe went into the sugaring business with Jeanette and Gert.

Come spring, when the sap was running, he would snowmobile up into the sugar bush beyond the chalet and tap the trees. He had tap lines that went down from the trees into a metal tank at the sugarhouse, and when the sap ran, it went down into the tank. Joe made some of the finest syrup around, and sugaring time was a happy time at the old homestead. He also had a wood-burning sugar shack. He cut and split all his own wood. Friends would come from miles around to sugar with Joe.

One year, Halley's Comet lit up the night sky as the sparks came out of the chimney of Joe's sugarhouse. A sugar on snow party was a celebration to be remembered, with hot cider, cake doughnuts, pickles and warm maple syrup served on snow. Hot syrup was poured on the snow, and it turned it into maple taffy. The combination of the taffy, the pickles and the doughnuts, along with the friendship of neighbors as spring broke, was and remains a jewel of a time.

That time of year, around the spring equinox, all of Lamoille County had smoke coming out of sugarhouse chimneys up and down dirt roads. Most use plastic tubing for the sap, but on back roads in Sterling Valley, old Farmer Percy still hangs some tin buckets from the trees.

Mama at age ninety-two, reading the front page of the *Burlington Free Press*.

Mud season sets in, and you better know how to drive with some muscle. The muddy roads wear deep grooves and crevasses soupy and sticky. Low-riding cars could sink in and be stuck if the driver doesn't keep up momentum. Saabs take it tough. Four-wheel-drive and studded snow tires will get you through, especially in an all-wheel-drive Subaru Outback, known as "the Vermonter," the most popular car on the road in these parts. It'll get you where you want to go, deep mud or deep snow. Gert and Jeanette have four-wheel-drive Fords.

If walls could talk, the Lepine Girls' dining room would be an eclectic forum of historical notes. Folks from many walks of life have sat with them in the dining room at the farm, shooting the breeze, discussing politics, literature or the latest triumph or tragedy happening in the world at large, as well as the up-to-the-minute news in Mud City: deaths and weddings, babies and holidays, what land is being developed in Lamoille County and the size of the buck the young girl down the road just shot.

By 1991, Gert and Jeanette were milking sixty-five prize Jersey cows, rated number one in the United States. Therese was always there to help, and so was Mama. One early morning, the president of the American Jersey Dairy Association came by the farm for a visit. He loved the farm and thought the world of the Lepine Girls and the life they led. He asked Gert if Mama was still "doing the morning dishes" in the barn after milking. Just then, Mama, dressed in blue jeans, came into the barn. It

was seven o'clock in the morning and time for her to get to work. She was ninety-two years old.

When Gert was reading the next issue of the *American Jersey Dairy Association* magazine, there was an article about Mama Lepine and how she was still working in the barn at her age. Gert shared the piece with Mama.

Mama said, "So, what's the big deal?"

The Land Rover car company shot a commercial on the farm. Francis Ford Coppola paid a visit. Gert said, "I'm still waiting for my Land Rover. It still hasn't arrived." She laughed.

A friend recalled a visit she had at the farm. She said, "It was a summer day. On their clothesline hung several pairs of blue jeans and T-shirts, blowing in the breeze. Jeanette was in her seventies, had her red kayak up in the bed of her truck. I opened the screen door to the kitchen, and there she was, stirring up a big pot of black raspberry jam on the stove. The place had the scent of a fusion of wild blackberries and the fresh mountain air coming through the open windows. Her sleeping bag was rolled up on the dining floor with her one-piece polka dot bathing suit."

Jeanette said, "I'm driving up to Canada. Going camping with Ojibwa Indians. Bringing some jam along."

Jeanette had communicated with the Vermont legislature when Governor Howard Dean was in office with the hope of legalizing hemp. Back in the 1980s, Jeanette pushed for hemp production to become a legal crop for farmers here.

Jeanette haying at Mount Sterling Farm.

Stowe farmer Paul Percy's Jersey calf eating buttercups in a West Hill pasture in Stowe.

Why hemp? Jeanette said, "Because hemp can be combined with other natural fibers, silk and cotton, for instance, made into beautiful fabric made into fine, breathable clothing. Hemp seeds are edible and very nutritious. They contain all the essential amino acids needed for a healthy diet. Hemp growing in the States would give farmers a whole new opportunity for sustainability and a lucrative way of life." An environmentally sound product, she felt it would give farmers another cash crop. Dairy farms were being bought up and sold to developers. Many farmers couldn't make ends meet.

Jeanette said, "There isn't a crop around that has so much potential as the production of hemp, and it's biodegradable." In 2012, at the age of eighty-two, Jeanette still believed in the goodness of the hemp crop. She said, "I understand the viable, wonderful upswing it could bring to farmers' economy and lifestyle and help heal the environment." Jeanette, like Gert, has never lost her joie de vivre. She explained how hemp—or low tetrahydrocannabinol (THC), strains of the cannabis sativa plant—is used in other countries, with China at the forefront, for textiles, fabric, fuel, biodegradable plastic, rope, water and soil purification, in moisturizers and as weed control, as well as construction materials, jewelry and for nutritional use. Hulled hemp seeds are rich in protein, fiber, linoleic acid 18:2-(Omega 6), linoleaic acid 18:3-(Omega 6), vitamins A, B1, B2, B6 and E, calcium and iron.

The dedication of the Bishop Marshal Catholic School in Morrisville, founded through Mama Lepine's contribution. *Left to right*: Father Dennis, Gert, Jeanette and the Bishop of Burlington, with Therese in the wheelchair.

Although the United States in the leading importer of hemp, it is illegal for anyone to grow it in the States. It is legally grown in parts of Europe, Southeast Asia, Canada, Chile and North Korea. Although Jeanette, along with other Vermonters, communicated with the Vermont legislature in hopes of some help in changing the laws, it hasn't happened yet.

Why does law enforcement uproot it when it grows wild? Why, when more than thirty other countries recognize it for its benefits to the climate and to people, both business-wise and health-wise? Maybe in Jeanette's lifetime the change will finally come—Vermont has the perfect soil to produce the crop.

As Gert said, "People in the United States get it confused with marijuana, but hemp is a good plant, and it could really help out the farmers." This is especially true during this era, when low dairy prices have brought economic devastation to scores of farmers.

HEAVEN-BOUND MAMA LEPINE

A mother is not a person to lean on but a person to make leaning unnecessary.
—Dorothy Canfield Fisher

Mama passed away at Mount Sterling Farm at the age of ninety-five in September 1995. Those who were fortunate to have known Imelda celebrated the beauty of her life at a gathering held in her honor at the Jacob Walker Art Gallery located in the Morristown Store Building (which Jeanette and Gert had bought at one time at auction) at Morristown Corners on Stagecoach Road. The public was invited to an exhibition in tribute to the Lepine family by honoring Imelda.

People brought their stories, anecdotes and photos to the gallery on Sunday, October 1, 1995, from 1:00 p.m. to 2:30 p.m. and joined the Lepine family at the gallery. Hot cider and homemade cookies were served. Her hand-woven rugs were displayed, and images of her graced the walls. The exhibition was displayed at the gallery from October 1 to October 14.

Jeanette and Gert handed out piggy banks that Mama had collected over the years to the children in attendance, and each child was given $100 in her honor. If anyone loved children, Imelda did. Guests brought poetry and prose that they had written about the lovely Mrs. Imelda Paiement Lepine. She was remembered as a lady of a gentle nature, exuding a deep strength—a true woman. She wore time well up until the end. Age had brought refinement to her features as her snow-white French twist accented high cheekbones and an ever-sweet smile. Her legacy was her children, who will always be so very proud and grateful for "Mama." When they speak of

her, it is with deep reverence. Gert said, "Though Mama had many worries, she never complained. I never saw her cry. After she died, I found some letters she wrote to her sister about the hard times. But though she wrote the letters, she never mailed them."

Instead, she held on through the storms, both literally and figuratively. She passed on her joy and passion in her connection to the earth, a driving love of being so entwined with the magnificent natural environment of Vermont. She was the one who taught them the principal of giving. After her death, Gert drew an analogy about Mama's philosophy on life with John F. Kennedy's inauguration speech. Gert said, "Instead of 'ask not what your country can do for you, ask what you can do for your country,' Mama taught us to ask not what your family can do for you, but what you can do for your family."

The green meadows of Mud City and Sterling Valley were a glorious sight to behold on the day of her passing—Imelda played such an amazingly strong part in the acquisition of this land. Her deep, loving and courageous spirit lives on in her children and in the fertile and majestic state of Vermont that she so wholly embraced. The memory of Imelda Lepine will always be "embracing Vermont."

The softness of her voice remained with her until the end. Her beads were worn like her hands, and she prayed her rosary in French without missing a phrase, as she had through all the lean times, the good times and the in-between times.

In her last days, I sometimes sat with Mama. She would sometimes sit outdoors, surrounded by the fragrant summer breeze, rich with the sounds of the bustling farm and birds chirping, the air pregnant with the scent of fresh-cut hay and the front of the old gray farmhouse colored with her old-fashioned pink and pale-white hollyhocks that she had planted that perennially bloomed.

THE LEPINE GIRLS AUCTION OFF THEIR PRIZE-WINNING JERSEYS

A man or woman growing old becomes a child again.
—Sophocles

After Mama died, the Girls were feeling like it was time to move on to adventures for themselves other than what the farming life had brought them. Therese suffered a stroke. An old ski injury that Jeanette still suffered from had made her slow up a bit. Gert had depended on Jeanette as her co-manager. They had always been a team. Gert was sixty-eight at the time, Jeanette was sixty-six and Therese was seventy-one. Gert had farmed for more than forty years. Wouldn't it be great to see some more of Vermont? Take drives on yet undiscovered backcountry roads and fish again like they had as children? There were so many art galleries to explore!

They decided to auction off their prized Jersey herd. The auction took place at the farm in the summer of 1996 under a festive red and white striped tent. Trucks with license plates from California, Utah and Colorado pulled down Mud City Loop to join up with farmers from all over Vermont and other parts of America to watch the show and make their bids. Bids were called in from out of state. In 1952, when Gert was in her early days of dairy farming, there were 11,000 dairy farms in Vermont. At the time of the auction, there were a mere 1,200.

The *New York Times* and the *Los Angeles Times* compared Gert's Sterling Jerseys, at auction, to Jackie Kennedy's pearls at auction at Sotheby's that same year, 1995. But Jackie's pearls were faux. Gert's Jerseys were real, with milk as pearly white and pure as it came.

Gert didn't show much emotion as their beautiful "pearls-o-girls" were trucked up to be taken to other farms. Jeanette, on the other hand, had tears running down her cheeks as she milked Goldie one last time. "I was in the barn, and I heard Veronica being bid on, and then she was put in the truck that would transport her to a farm out west. The tears poured out of my eyes."

Gert said, "Cows were part of my life for a long time, but I can accept the fact that they'll be gone. On the other hand, I can never live happily without my land."

As it states in the Bible, "To everything there is a season and a time for every purpose under heaven." It is a wise person who understands and accepts this and, in living each day, is fully present in the moment and the task or pleasure, sorrow or joy that is at hand. Life then has a very deep and joyful meaning. Gert and Jeanette knew this and still do.

Cattle trucks came in droves up and down the winding dirt roads of Mud City Loop, pulling into Mount Sterling Farm for the big Jersey auction. Bids were phoned in from out west, the Midwest and the East Coast. It was a standing room–only crowd.

One neighbor, Mrs. Zuber, brought a basket of marigolds and daisies, with a note, "We won't call it retirement." She hung the basket under Gert on the rail around the auction pen.

While Gert and Jeanette were milking at Mount Sterling Farm, Veronica produced more than 140,000 pounds of milk. Gert said her goodbyes as this beautiful bovine was taken in a truck down the dirt road on Mud City Loop to her new home, a farm in Utah. Veronica sold for $8,500.

A new life had begun for the Lepine Girls. Marie was still out west with Othmar, and Mama had passed away, so Mount Sterling Farm was a women's farm run by three women: Gert, Jeanette and Therese. Jeanette and Gert were and still are best friends. Buddies and co-workers. Always have been.

KAYAKING DAYS FOR GERT AND JEANETTE

The two best reasons to buy a kayak rather than just renting are sunsets and sunrises.
—Thomas P. Jones

Gert said, "We tried canoeing, and then Jeanette bought a kayak down at Umiak. I'm no water bug. As a matter of fact, I can't swim a stroke, so it took me a while. But a lot of our friends were going…It's nice for older people. We're not looking for the kind of wild adventure you can find with whitewater or sea kayaking."

Jeanette added, "One of the nice things about kayaking in a small one…is there isn't a lot of preparation. We just put it in the back of the truck, pulling up at the lake or river we want to explore. You become very much immersed in the natural world."

A few summers ago, Jeanette went kayaking up in north Ontario with the Ojibwa Indians. She brought them gifts of black raspberry jam she made in her own kitchen, locally grown medicinal herbs and maple syrup from Sterling Maples. They fished, sometimes in full view of moose and wolves. Getting right up next to wildlife is part of the attraction.

"Besides the laughs and the good company, it was the sighting of a family of loons that really got us hooked," said Gert. Loons are particularly captivating, because of both their entrancing call and their unusual characteristics. You'll never see loons on land—they can't walk. Their legs are positioned in such a way that they can't keep their balance. The slender aquatic diving birds spend most of their time on or in the water, where they

mate and hatch their young. In the fall, they head to the ocean or to the bays, such as the Chesapeake. When they choose a nest during the warm months, they look for a small patch of land where they won't be bothered by predators, such as raccoons or seagulls.

"I remember a day last autumn," says Jeanette, "when we witnessed a parting of the parents and their young. The parents are always the first to leave, and they mate for life, by the way. They were getting ready to go. It was the most boisterous sighting of loons so far."

Gert added, "To fly out of a small pond, they need to circle and circle. On this particular day, they flew in and flew out several times. When the mother flew in, there was a lot of welcoming. It's almost like they're human with emotions. When the parents left, the mournfulness of the babies' cries was very touching." Gert said, "Morning and dusk are the best times to paddle. The shadows and light are so beautiful at those times of day."

"Once...very early in the morning, we heard the shrill cry (the tremolo of the loon). It can send shivers up your spine. Sometimes you can hear them talking to each other (called *kwuks*)," said Jeanette. If you get close enough, you'll see a very unusual characteristic: loons have scarlet eyes.

On another adventure, Jeanette recalled peering down near her toes one fall day and watching life begin. "It was a day in November, about sixty degrees. I was right on the edge of the river in about a foot of water. It was crystal clear. It was so shiny, and here underneath the lichen were all these brook trout spawning. I could have just grabbed one."

By the end of their days on the water, the sisters and their boats are practically one. As Gert says, "The hardest part of kayaking is getting out of one." As this book is being written, another spring is upon them. Gert is wondering if she will be able to get out of her kayak this year.

Jeanette advised her, "Just build up the height of your seat with a stack of pillows. You'll be fine, Gert. Don't worry."

As the saying goes, "There is nothing to fear but fear itself." And it appears that the Girls have lived their lives by that creed. As a matter of fact, when Jeanette was with the airlines, she was presented an award for the many times she had crossed the equator in her career as a stewardess. They have never dwelled on the negative and are always there to lend a helping hand to their neighbors.

JEANETTE

A Key Player in the Morrisville Community Garden

God Almighty first planted a garden and indeed it is the purest of human pleasures.
—Francis Bacon

In 1995, Jeanette was approached by some locals concerning a community garden for folks who wanted to grow their own fruits and vegetables but didn't have the land. There is a field in Morrisville called

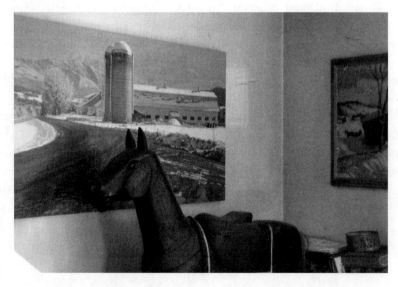

The antique horse that Jeanette acquired during her Mud City market days.

the Oxbow. The town received a grant, and the Morristown Community Garden was created.

Local Frank Huard was the one to approach Jeanette, and she in turn talked to Carol and Bill Jennings, who were renting one of her properties.

There are about thirty plots at the garden. It changes from year to year. The field is rototilled every year. In the past, Jeanette and Gert would arrive on the scene with a truck full of their cows' manure and spread it around on the field. Organic fertilizer has also been used. Water is available from spigots thanks to the town. Locals remember Jeanette coming to the garden to give new gardeners classes.

In the past, every Labor Day weekend, a corn roast was held at the field from five o'clock in the afternoon until about eight o'clock at night. Always there was live music.

Twelve dozen ears of corn were soaked and roasted, and at each corn roast there were forty homemade pies from which to choose.

In years past, there has been no charge for a garden plot. There was a donation gallon jug at the corn roast for people to have the opportunity to support the garden. One year, there was a donation of a $100 bill with a note attached, "Please get better hot dogs!"

SEASONS OF BIG CHANGE AND VERMONT LAND CONSERVATION

The land is always, always there for you. It's up to you what you do with it.
—Gert Lepine

After the Girls retired and signed a lease with a tenant farmer, Randall Harrington, he farmed for a while. Then, one night in 1997, neighbors heard the scream of fire trucks headed for Mud City and saw the flames in the distance. Due to an electrical wiring problem, Mount Sterling Farm's big old green barn was in flames. It burned to the ground. No one was hurt.

In 1998, they had the barn rebuilt. Therese died in the summer of 2010 on June 22 at Mount Sterling Farm. She had strokes and was lovingly cared for at home for some time. Up until the end, Therese had a cheery personality. She loved to laugh. After the strokes, she couldn't talk but she could laugh. "Therese did not hurt. She died during the night," said Jeannette.

Over the years, the Girls had come to realize that the land was something they must protect. In a way, those acres were their children. Between Gert, Jeanette and Therese, they conserved 1,100 acres of Vermont farmland. They have conserved 840 acres of land in Mud City. Gert was the first to conserve. In 2007, she conserved 640 acres. Jeanette conserved 220 acres. Therese conserved 82 acres.

Gert said, "It's forever. People young and old can enjoy the beauty of the land. I figure, I've gone through one thousand cows in my life. Cows you figure won't always be with you. The land becomes so familiar to you. You know where every stone is, and Mud City is a big attraction. Sterling Mountain is *so* beautiful!"

Embracing Vermont

The Land Conservation Easement on their adjoining properties was accomplished through the Vermont Land Trust. With the Stowe Land Trust, Gert conserved forty-seven acres—woods, meadows, pastures with spectacular views and natural vistas showing off maples, evergreens and spruce. Gert said, "Our land can never be built on. We have two acres left, which will stay with the farmhouse."

The Lepines still owned land, paying taxes and keeping the right to sell, but the conservation easement is a legally binding agreement that their land will never be subdivided or developed. Two and a half miles of the three-hundred-mile Catamount Trail run through the rolling hills and fields of their land, with one-of-a-kind views of the Sterling Mountain Range, all conserved for the use of the public. Here in the fresh mountain air, a divinity reigns. You may walk among the wonders of nature, refreshing your soul, body and mind.

This natural haven is a special place for the pleasures of farming, cross-country skiing, snowshoeing, hiking and mountain biking—just a few of the joys available to all who venture out here among wild animals in their natural habitat and the beauty of the flora, fauna and landscape.

In Vermont, land conservation easements are a way to preserve their land from harm and development, keeping the landscape natural where forests can grow and farms of all kinds can thrive. Wildlife can live and propagate, and people can enjoy the healthful beauty of the natural world.

Gert had got the idea first to conserve 47 acres through the Stowe Land Trust. The rest of the conservation was accomplished through Vermont Land Trust; 840 acres of Lepine property has been conserved in Mud City. Gert says, "Money can only buy so much, and I can never put a price on this property. It's priceless."

Between 1979 and 2009, more than 500,000 acres of Vermont land has been conserved. Gert sold Mount Sterling Farm to two Vermont boys, Scott and Randy Bidwell, on October 12, 2010, leaving the farmhouse for Jeanette and herself, as well as 2 surrounding acres. They own the remaining conserved acres belonging to the late Therese, as well as their own.

CONCLUSION

Thou nothing can bring back the splendour in the grass, the beauty of the flower, we shall grieve not, but rather, gather strength from what remains behind.
—William Wordsworth

Able-bodied farmers, with the strong hands and backbones needed to work the soil, using logging bobs and axes, plows and rakes, harnesses and pitchforks, are fading in numbers. Dairy farms are disappearing. The "real McCoys" have reached old age. But people young enough and driven enough to pursue the agrarian way of life are diversifying their crops, and Vermonters are predominately localvores. "Be green" is a new mantra. Without the green of the trees and the grass, we will all die or be plagued with disease (dis-ease).

"Carbon footprint" is the new catchphrase on people's tongues, as the scent of sweet hay in the air, in some places, is gone. The Lepines were "green" before "being green" became a cutting-edge mantra. In many areas of the country, people are breathing the rank air of industrial fumes instead of luscious natural scents. In many developed areas of the United States, there are no birds to bring in the spring with song. They've vanished with the farmland, along with a good portion of the healthy, contented, rbST-free cows, milked oh so dedicatedly by farmers every morning and every afternoon, 7 days a week, 365 days of the year. The corporate ideology for productive dairy farming—"forcing higher milk yields out of every animal unit"—sends a shiver.

Gert's famous hands working the soil for planting, age eighty-five.

Not so many socks or sweaters are knitted from sheep's wool yarn. Millions of people wear clothes made from the same petroleum products that make their plastic bags—fossil fuels.

Fresh eggs gathered and sweet strawberries picked, along with fresh corn and tomatoes for canning and eating off the vine, are in so many places becoming just memories of an agrarian society almost gone, in good portion—the way of the silo filled with silage and the big family table in the kitchen, where the healthy meals were served up. But there's a revival on the rise, for these are cornerstones of civilization. Fresh food networks, farm-to-school programs and the mentality "Know your farmer, know your food" are strong in Vermont.

Fences and stone walls are being built by hand. Land is being ploughed for crop planting with the hope of a glorious harvest. Many gardens here use only organic seeds.

The typical aim for a farmer at the end of the day is the satisfaction of a job well done and a good night's rest—with dreams of a ride up on a tractor the previous day, when the dew kisses the grass of a summer's morn. It is good to drive by Mount Sterling Farm and see Jerseys in the meadows.

How many will taste the first maple sugar of the season hot off the wood burner? Prize an orange for Christmas and a candy bar after church? Fresh

Jeanette carving one of her pumpkins into a jack-o'-lantern, autumn 2011.

milk? Mama's pies? Trout fishing and kayaking in a lake that echoes the *kwuks* of the mother and father loon as they teach their young independence? Many, I'm hoping, for these are some of the precious joys that contribute to rich and rewarding lives.

Rural Vermont and genuine farm families like the Lepines and their lands are disappearing. Less than 9 percent of farmers in Vermont were women in 1989, and out of any type of farm, women-run dairy farms were the rarest.

Up in Sterling Valley on West Hill in Stowe there is now a goat cheese farm called Sage Farm Goat Dairy. The cheese, in the French tradition, is named for the region. Two of the cheeses offered are Sterling and Madonna, adjoining mountains. The cheeses are out of this world.

There are local farmers' markets where the sheep farmers sell lamb for kabobs and sheep skins, which are a fine choice for baby blankets. Bambi Freeman, a shepherdess in Sterling Valley who sells them at the farmers' markets, said, "The reason they are so safe for babies is that the wool strands are hollow in the middle. A baby can't suffocate." The lanolin is soothing, too.

Vermonters are aware of the dangers of chemically altered food, a health risk for millions of people, especially combined with sedentary lifestyles. People with thin, lithe bodies brought about by active lifestyles and organic

Jeanette reading over the manuscript for this book.

food and pure dairy products are on the rise—practicing yoga, swimming daily and vigorous walking. It's part of a way of life for so many people here.

Returnable glass milk bottles have been replaced with plastic, and as of today, the unrecycled plastic bottles used every year in the United States could circle the circumference of the earth 190 times. Instead of paper bags, people around the world use 1 trillion plastic bags per year—1 million plastic bags per minute. But Vermonters are recycling. Not only plastic, glass, cardboard and paper, but in Stowe, many people also recycle their clothes.

It is becoming common knowledge that nurdles, "plastic scrap" created from plastic manufacturing plants, are washing up in the tide lines and make up most of the beach garbage at many beaches. They are exceptionally poisonous constituents of the ocean's flotsam, resembling translucent fish eggs. Fish mistake them for food and consume them. They contain the poisonous chemicals DDT and DDE. Every year in the United States, 27 million tons of nurdles make their devilish way into the environment.

Plastic, along with herbicides, pesticides and other poisonous substances, used in massive amounts, has accumulated in the environment and immersed itself in plant life, sea life, animals, human beings, the air and the sky.

Jeanette working in her strawberry patch.

On a positive note, modern Vermont farmers are not just diversifying; many have gone completely organic as well. The legacy of the Lepines of Mud City can live on through the land that they have conserved for future farms, keeping alive through nature the spirits of Tante Eva, Uncle Luger, Maurice, Irenee, Wilfred, Lawrence, Andre, the Girls, Marguerite D'Youville and beautiful, brave Mama. I can almost hear the sound of the children's laughter as they run through the wilds coming home from school.

May the inspiration of the Lepine family of Mud City, Vermont, continue to influence the lives of others looking for freedom and independence at the place they call home.

Gert Lepine said, "I wish we could start all over again."

AFTERMATH

Over the years, the Lepine girls were happy to share their life stories with me. They had one stipulation: "Before it is published, we want you to go over the whole piece with us."

On Wednesday, April 4, 2012, the Girls were thrilled with the story. It was interesting the way we wrapped it up. Gert took me downstairs to see the

Jeanette toasting the book. "A votre santé!"

jelly cupboard that she and Jeanette had made for Mama. It was filled with old French wine and spirits from Jeanette's flying days with Pan Am. Gert, who I have only known to drink raw milk, pulled out a vintage 1936 bottle of French cognac and said, "Come on! This calls for a toast!" She brought the bottle up to the dining room and took out the glasses. Gert, Jeanette, Marie (now eighty-eight!) and my husband Jake and I toasted with a feeling of joy and camaraderie.

And so we toasted with laughter and good cheer, "A votre santé!" And to the health of Vermont and all that is hers.

RECIPES FROM MAMA LEPINE'S VERMONT FARMHOUSE KITCHEN

I n the Mount Sterling farmhouse dining room hangs a Rockwellian image of Mama. In her eighties, wearing a cotton dress and apron, her white hair arranged in a classic French twist, she wistfully smiles, holding her golden-brown lattice-crust pie for presentation with her can-do hands.

When I commented on the photograph recently, Marie went into the kitchen and came back with a few of Mama's recipes that she copied for me. Loving to cook, I included some other favorites that I have served at my house or have enjoyed at some time in my life, as well. I pass these recipes along to you, with the hope that they may become part of your family's traditions as well.

MAMA'S TOURTIERE: TRADITIONAL FRENCH CHRISTMAS PIE

A popular dish throughout Quebec during the Christmas and New Year's holidays. The name originated in Quebec, derived from the deep-dish ceramic casserole in which it is baked.

2 lbs. ground pork
2 lbs. ground beef or venison
1 medium onion, chopped
salt and pepper to taste
$\frac{1}{2}$ tbs. crushed cloves
3 cups of water (add more, if necessary)

Blend and cook this mixture on a stove-top burner for 1 to 1½ hours on low heat, stirring occasionally. Place layer of crust in la tourtiere, fill with mixture and cover with crust. (See following recipe below for pastry crust.) Bake at 375 degrees Fahrenheit for 45 minutes.

PASTRY CRUST
2 cups unbleached flour
1 cup salted butter
ice water

Preheat oven to 275 degrees Fahrenheit. Mix dry ingredients together. The butter needs to be chopped with a pastry tool. Knead the dough so the butter is well mixed into the flour. Take a couple ice cubes and add cold water. Pour the cold water through your fingers into the dry ingredients and get a consistency that is thick but malleable. Make the dough into a ball, cut it in half and then roll out thin, for placing on the bottom and top of the tourtiere.

Mama at Thanksgiving in the kitchen at Mount Sterling Farm, holding her freshly baked pie.

MAMA'S RAGOUT DE BOULETTES

This recipe can also be made with pigs' feet instead of lean pork, thus "Ragout de Boulettes et Pattes de Cochon." Ragout is a French word for stew.

1 small onion, chopped finely
1 tsp. mild drippings (fat)
2 lbs. ground raw, lean pork
1 stalk diced celery
½ tsp. cinnamon, allspice and cloves (each)
4 cups full, hot meat stock or broth
flour and salt and pepper to taste

Note: This traditional stew may also be made with chicken, beef or veal.

Brown onion, lightly, in lard drippings. Add ground pork, with celery and seasonings. Shape into balls about 1½ inches round. Drop meatballs into boiling broth and simmer for one hour or less, until cooked through. Thicken the gravy with browned flour. Makes 8 servings.

POMMES DE TERRE FRITES (FRENCH FRIES)

Wash and scrub russet potatoes—two potatoes for a big appetite or one potato for a child or for a person with a small appetite. Slice potatoes three-eighths of an inch with a sharp vegetable knife or a mandolin, using the julienne blade. Cut a paper bag, so as to have two large rectangles. You will use these to place your potatoes on after frying.

Take a heavy metal pan and cover with five inches of vegetable oil. Heat the oil to 325 degrees Fahrenheit and use a thermometer to monitor the heat. Cook in small batches for about 5 minutes. With a slotted spoon, place on the brown paper bag. In a few minutes, begin the frying process again. This time, fry until crunchy and golden brown. This will take about a minute and a half. Salt to taste.

POUTINE

This is a dish of homemade French fries (Pommes de Terre Frites), served with fresh cheddar cheese curds (that squeak to the tooth, made fresh that morning) and velouté (a warm, "velvety" chicken gravy).

Make French fries. Cover with a handful of cheese curds and velouté. In Vermont, many farms sell cheese curds. Cheese curds should be fresh the day the poutine is made.

CHICKEN VELOUTÉ SAUCE

One of the mother sauces of classical French cuisine, the name translates to "velvety." It is used in poutine and is also the base for sauce mushroom, aurora, supreme and allemande.

2 cups chicken stock
pepper to taste

FOR THE BLONDE ROUX
3 tbs. salted butter
flour to thicken butter

In a heavy saucepan, melt the butter. Slowly sprinkle and whisk in the flour until a smooth golden paste is made. Be careful not to brown or burn this. Slowly add the chicken broth and keep whisking until the broth is thick enough to coat a spoon. Cover and keep on warm for serving. Serve on French fries and cheese curds for poutine.

LES PETTES DE SOUER (NUN'S FARTS)

This recipe is made from leftover dough of tourtiere. I baked it, and it's quite delicious! Amusing name. Not one of Mama's.

Roll the dough into a long, thin rectangle. Spread a thin layer of butter, brown sugar, cinnamon and maple syrup onto the dough. Sprinkle on currants or raisins if you wish. Chopped walnuts are a nice touch. Roll

into a log, like a jelly roll, and then slice into thin sections. Place individual triangles into muffin tin sections. Bake for 20–25 minutes at 350 degrees Fahrenheit.

MAMA'S MAPLE SYRUP DUMPLING

2 cups pastry flour
1 tsp. baking powder
1 tsp. salt
2 tbs. butter
¾ cup of milk
2 cups maple syrup
2 cups boiling water

Sift together flour, baking powder and salt. Cut in butter and add milk to make a soft dough. In a saucepan, bring maple syrup and water to boil. Drop dumplings into syrup, and then cover and cook for 20 minutes. Serve hot.

MAMA'S HOMEMADE HONEY

10 cups sugar
3 cups water
½ tsp. alum
80 blossoms of white clover
40 blossoms of red clover
5 rose petals

Combine sugar, water and alum and boil for five minutes. Pour syrup over blossoms and rose petals and let stand for twenty minutes. Strain the honey through a cheesecloth bottle. Store in a dry place!

MAMA'S PATE CHINOIS (SHEPHERD'S PIE)

4 tbs. melted butter
1 lb. lean ground pork

1 medium onion
1 lb. corn
3 cups mashed potatoes

Put half the butter (two tbs.) in a skillet with meat and onion. Cook until brown, breaking up meat evenly. Spread the meat in a 2-quart casserole, cover with corn and then the hot mashed potatoes, top with remaining butter.

Heat in moderate oven at 350 degrees for 20 minutes or until lightly browned and then serve.

SUGAR-ON-SNOW

If the party is in the sugarhouse, prepare dishes of snow. If it's held outdoors, the maple syrup can be poured right onto the snow. The snow is not eaten but rather is used to cool the syrup. One can twist it around a spoon, the way one eats spaghetti.

Boil the maple syrup at 232 degrees with ½ tsp. of butter. Pour it over the snow to cool it down. Serve it with sour pickles and cake doughnuts. Enjoy!

There's something about Vermont and maple syrup, kind of like mom and apple pie. Maple syrup conjures up so many memories for so many, especially when cooking with it. Many can relate to this poesy, titled "Spring Celebration in Vermont," by Evelyn Grace Geer:

> *When fragrant flora frame muddy roads with bright blossoms in budding reverence, maple sap drips into tattered tin buckets, tapping out a joyous percussion to peepers' measured, orchestrated songs about life. Baby does and baby cows, baby foxes and squealing sows greet the brilliant, vernal light. Warm days melt into navy blue nights decorated with stars, and sugarhouses spout sweet smoke. Wood-heated sap evaporators bubble, steam and boil.*
>
> *And the mountains celebrate; dressed in pink, Earth warms under balmy, breezy days. Air and sky and a scent of spring inspire the locals. They order garden seeds from catalogues. Tomatoes, green beans and some luscious sweet peas. Vermont goat farmers are making fresh cheese. Cake donuts, sour pickles, spiced cider, maple taffy or "sugar on snow." And, of*

course, fresh milk from Vermont Jerseys' udders. Snowflakes fly wildly still. March madness always give us our fill. Mother Nature's perfect circle turns with the warming sun.

Sugar on snow parties have just begun. Spring's a really sweet time in Vermont. Maple syrup reminds of that all year.

God Bless us all.

Beautiful Mama Lepine, matriarch of the Lepine family.

SOME INTERESTING FACTS
ABOUT VERMONT THAT
MAKE IT UNIQUE

If anyone loved Vermont as the Lepines have, it was the sixteenth U.S. president and his family. During the summer of 1863 and 1864, as the violence of the Civil War raged on in the South, the abolitionist president sent his wife, Mary Todd Lincoln, and their children to Manchester, Vermont, from the White House. They vacationed at the Equinox Hotel, built in 1769. The inn was built on the 2,300-acre property, with 180 rooms. Old maple trees lined the streets of the quaint village, where the sidewalks are made of white marble brought in from Proctor, the state's marble capital, named for the Proctor family, the marble barons of Vermont.

Mrs. Lincoln had planned on returning to Vermont during the summer of 1865. That spring, General Robert E. Lee (whose nickname was "Marble Man") of the Confederate army surrendered to General Ulysses S. Grant, who went on to become the United States' eighteenth president, at the Appomattox Court House in Virginia. The war ended, but Confederate sympathizers were still afoot.

On April 14, 1865, Mr. and Mrs. Lincoln were attending a performance of *My American Cousin* at the elegant Ford's Theatre in Washington, D.C. John Wilkes Booth chose a scene in the play when the audience would break up into loud laughter. Then he shot President Lincoln from behind, firing a bullet into his head. The president died the following day.

It is said that Mrs. Lincoln suffered from hysteria and eccentricities, and although she never returned to the Equinox in her lifetime, there are ghost stories there about her presence. Based on pictures of Mary Todd Lincoln and her children, there have been apparitions of her and one of her sons

at the inn. Mysterious, whispering, ghostly voices are heard, and lights blink on and off without warning at the hotel. The ghosts are friendly, though. Nothing to fuss about as yet.

The rough-and-ready Green Mountain Boys, a Vermont militia group, with its leaders—the tall, brawny, swashbuckling Colonel Ethan Allen and his brother, Ira—used to gather in the Marshfield Tavern at the inn, built in 1769. They held meetings there, planning their strategies to protect states' rights and keep away the "Yorkers," who were attempting to take over Vermont land. The Green Mountain Boys controlled Vermont from 1771 to 1775.

Ethan Allen's voice filled the tavern on many days and evenings as he commanded the meetings. With a sword by his side, his coat was decorated with gold braiding on the shoulders and epaulettes. The rest of the Green Mountain Boys had no special uniforms except for a sprig of fresh Vermont evergreen decorating their caps.

I found a beautiful picture on the back cover of an antique magazine while visiting the Girls at Mount Sterling Farm. It is of a Vermont Green Mountain Boys flag. The flag, from the Civil War era, is an amazing piece of art. It is made of hand-sewn silk, with gold stars surrounding the group's name. It is enhanced by a small, hand-painted portrait of George Washington. On the other side is a gold American eagle, with a breastplate of an American flag, an arch of thirteen stars and an emblem of the words "E Pluribus Unum" grasped in the eagle's beak.

This rare and beautiful flag is an indication of the pride that the Green Mountain Boys took in serving their country, as well as their ties to great artistic taste. A picture of it is contained in this book. (Note that Ethan Allen and his charges were from a much earlier time than the Civil War, but the flag expresses how the spirit of the Green Mountain Boys prevailed.)

Ethan Allen died two years before Vermont became a state, on February 12, 1799, the father of nine children by two different women. He was supposed to have been buried at the Green Mountain Cemetery in Burlington, Vermont. Due to some mix-up in records, the area was dug up in the hopes of locating his burial plot, but Ethan wasn't there. There is speculation of a secret burial elsewhere, but who can say?

Ira Allen, Ethan's brother, designed the state of Vermont's emblem, which features a cow (pronounced "kaaa-ow" by the locals), and he was also one of the founding fathers of Vermont. Ira was a well-known land surveyor in Stowe, owning the Onion River Land Company in town with Ethan. He

This page: Green Mountain Boys Civil War flag, front and back.

purchased large portions of property in Stowe, and due to his profession as a surveyor, he is believed to be the first white man to climb to the summit of Mount Mansfield.

More artists per capita call Vermont home than any other state in the country: musicians, potters, writers, painters, coffee roasters, weavers, sign carvers, quilters, calligraphers, photographers, cheese makers, glassblowers, furniture makers, metal workers, bakers and sculptors of both ice and stone.

It's not just the art, though. The pristine environment that the state embodies is intriguing. Vermont is the second-least-populated state in the country and the first state to ban billboards, primarily doing so in 1968, followed by Alaska and Hawaii. When one lives here all the time, it is easy to forget how jarring the billboard seen along an open road can be. Vermonters are spoiled that way.

If you're in Stowe on the Fourth of July, make sure to go to the "world's smallest parade," in a hamlet of Stowe called Moscow, Vermont. It's an annual celebration, and the locals ham it up.

When the romantic, balmy days of autumn arrive and the trees are dressed in their sparkling jewels, Stowe hosts the Oktoberfest. Come dance and taste German beer. Eat some bratwurst, too. Also held annually in Stowe is the British Invasion, when British car enthusiasts careen on winding back roads through the hills and the valleys. The antique car show happens every summer, with a parade through the village. There are dog shows and farmers' markets and…well, there's always something interesting going on it seems.

Johannes von Trapp opened the first cross-country ski trails in the area. It's such a wonderful way to be in and experience nature. There's a cabin at Trapp Family Lodge called John's Cabin. I used to ski up, doing the herringbone step. I would arrive with an appetite. The cabin would be nice and warm, with a wood stove, and there would be sandwiches and hot water for tea and hot chocolate. The honor system was in place. A hungry skier just put money in the jar. Cross-country skiing is a popular sport in Vermont. Norwegian immigrants brought this invigorating activity to the area in the early 1900s. They used it as a means of transportation, as they had in Norway.

There is a chapel on the property that can be reached by cross-country skis or a brisk hike. It is truly a sweet and humble little place to sit and pray or contemplate. It is a timeless treasure, named Our Lady of Peace in honor of the Blessed Mother Mary.

Lowell Thomas, broadcaster of radio hall of fame renown, broadcast over the airwaves from the Green Mountain Inn on Main Street in Stowe in the 1960s. Thomas had invited his friend, trick-shot artist and champion golfer Joe Kirkwood, to come to Vermont to enjoy a fishing trip with him and play some golf. Kirkwood and Thomas enjoyed teeing off at the Basin Harbor Club Course in Panton, Vermont, as well as at the Stowe Country Club. Although Kirkwood had toured the world twice with Gene Sarazen and Walter Hagen, this was his first visit to Vermont.

A marble bridge in Proctor, Vermont, built by the Vermont Marble Company, owned by the family of Redfield Proctor, the marble baron of Vermont.

Thomas fell in love with the state and moved to Stowe. He was a member of the Stowe Country Club, and it's been said that he was a major influence in Kirkwood being hired as the pro at the club, but I don't think Joe needed any introduction. He enjoyed his last nine years of life as Stowe's golf pro, and he did it with style. During World War I, he brought some laughter to wounded Australian soldiers with his trick shots. He turned pro at nineteen. Joe is interred off Mountain Road on Cape Cod Road; his gravestone was a granite rock from a quarry in Barre, the granite capital of the state. A bas-relief trick-shot club and a poem are engraved into the stone: "Tell your story of hard luck shots, of each one straight and true, But when you're done, remember son—That nobody cares but you." Joe Kirkwood passed in 1970. Lowell once said, "I just suspect that Joe Kirkwood did more to popularize golf than any other man who ever lived." For the past forty-five years, the Stowe Country Club has hosted the Joe Kirkwood Tournament. Golfers come from all over the world to play in the three-day event.

Aleksandr Solzhenitsyn, author of *One Day in the Life of Ivan Denisovich*, found comfortable refuge here, living in Cavendish after he was exiled from

This page: Mount Mansfield, Stowe, Vermont.

Russia. The townspeople protected his privacy. Solzhenitsyn said that he couldn't have imagined a better place to live.

Peter Schuman, a German sculptor, chose to live in Vermont and created masks and twelve-foot-tall puppets up in Glover. His puppet shows tell stories concerning morals and the state of the world—good versus evil, with good winning. Schuman's puppet show travels the world. The troupe returns to Glover in the summer for the "Bread and Puppet" theater. It is held outdoors in the countryside. Home-baked bread dipped in olive oil and garlic is enjoyed by the crowd, while they watch the grand puppet show.

Dorothy Canfield Fisher wrote volumes while calling Vermont home, as did the British Nobel laureate Rudyard Kipling. Though he was born in India, Kipling loved Vermont and found its environment most inspiring for his writing. He married Caroline "Carrie" Balestier in London, England, and then traveled with her to her hometown in Brattleboro, Vermont. They built a house there like a ship, naming it Naulakha, an Indian word meaning "precious jewel." Kipling wrote *Captains Courageous* and *The Jungle Book* here, although it was in India where he conceived of the ideas for these stories.

Kipling gave the Cub Scouts of America permission to use *The Jungle Book* stories as motivational instructional tomes. Kipling loved children, and when asked for his autograph, he made one stipulation: "Give two dollars to the Fresh Air Fund in Vermont, and I will sign your copy of my book." The Fresh Air Fund is still intact. Children who live in urban areas get to visit Vermont during the summer. They are hosted by Vermont families. No one knows how many children Kipling helped through his writing, but the spirit of giving is part of Vermont's charm.

Buried in Westminster Abbey next to T.S. Eliot, the United States Golf Association (USGA) credits Kipling for inventing snow golf while living in Vermont, a game played with red balls and tin cans for cups. It's a popular winter sport and a featured festivity at Stowe's annual Winter Carnival.

Kipling is just one of thousands of artists who made Vermont home. Every Memorial Day weekend, the state hosts an Open Studio weekend. Artists and craftsmen open their studio doors to the public. One can watch liquid glass blown and molded into elegant vases, lampshades, candlesticks, drinking glasses and glass beads. See a watercolor evolve, a violin crafted or Raku pottery fired in a kiln.

In the spring of 1970, Act 250 was passed in Montpelier, the state's capital, protecting Vermont land from development that would have put the well-being of the state's natural resources at risk. Rivers, wetlands, streams, lakes, waterfalls and the beautiful earth are cherished here.

Early on in the history of the country, Vermont proved to be a positive force in the growth of the national economy, as potash was a major contributor. Potash was the country's primary industrial chemical, used in dyeing fabric, baking and as an ingredient in saltpeter, used in making gunpowder. In Stowe, there was a potashery in town at what became Stowe's first guesthouse, now named Three Bears at the Fountain. It is located on the corner of Pucker Street and Route 100. Outside the inn is a gigantic ice sculpture that freezes every winter in shades of icy blue, formed by a natural spring that flows there.

Gristmills were located along rivers throughout the state, with two still standing in Lamoille County, where this story takes place. One is located on the road from Stowe to Jeffersonville over Smuggler's Notch. It has a waterwheel and is located on Grist Mill Road. The other is called the Power House Mill, located near the Power House Covered Bridge in Johnson on Route 100C near Johnson State College, northeast of Lamoille County.

Vermont is also the home of the most inventors per capita of all the states. The first patent was issued by George Washington to Vermonter Samuel Hopkins of Pittsford, Vermont, on July 31, 1790, under the patent statute passed earlier that year on April 10, for an improved process of making potash and pearl ash derived from a process of leaching wood ashes. Also signing the patent were Attorney General Edmund Randolph and Thomas Jefferson, acting secretary of state. Thaddeus Fairbanks of St. Johnsbury invented the platform scale, originally used to weigh hemp before it became illegal in the States. Illegalizing it was a bad idea, and Jeanette Lepine attempted to make it legal again, and with good reason. She's still hopeful. Fairbanks patented his design in 1830. Among his thirty-two patents, he invented the iron plow and artificial refrigeration, as well.

A neighbor of the Lepine Girls, Hollywood screenwriter John Fusco, wrote the screenplays for *Young Guns* and *Hidalgo*, as well as a novel titled *Paradise Salvage*, the controversial film *Thunderheart* and DreamWorks' *Spirit: Stallion of the Cimarron*. John founded an American Indian Horse Conservancy on his farm located just across the dirt road; many years ago, the Lepine children attended school there in a one-room schoolhouse called the Cole Hill School.

Vermont was the home of Sinclair Lewis and Grace Paley. Trey Anastasio of the band Phish, the band's lead guitarist and vocalist, is known "to crank it up" here. Jake Burton Carpenter of Stowe invented the snowboard, changing the world of winter sports forever.

The Front Four ski trails at Stowe Mountain Resort are the National, Star, Goat and Nose-Dive. The names speak for themselves. The 1937 *Vermont:*

A Guide to the Green Mountain State describes the last: "The Nose-Dive Trail (L.) 7.5 mi., is a sporty ski-run that swoops down Mansfield from the Nose and is temporarily climbed with the Long Trail, which crosses the road at this point. The downhill race of the championship meet of the Eastern Ski Association of America was held on this run in 1937, a distinction that could not be added to unless it should be chosen for the downhill run of the next international Olympics to be held in this country."

I've been down Goat *once*. I took the lift up to watch a slalom race when "Billy the Kid" and Susie "Chapstick" Chaffee were competing during Stowe's annual Winter Carnival in the 1970s. Ski-bumming was in its heyday then, and I was employed as a waitress at Ten Acres Lodge. It was great. Marie Nesky was the chef. The aging Ruth Spaulding was the chambermaid who taught me quilting. Ruth lived "downstreet" from the lodge in a farmhouse. A heavyset woman, she always wore her hair in a bun. She dressed in floral cotton dresses and an apron. Marie cooked up fresh brook trout at the lodge, local lamb and steaks. She broiled and boiled lobsters flown in from Maine and Boston. A perk for employees was a season's pass to Mount Mansfield, so I was on the mountain in the winter on a daily basis, in between serving breakfast and dinner to the guests at the lodge.

All of us locals would then head to the Baggy Knees, an old Mountain Road barn turned nightclub with live bands. Bobby Roberts was the bouncer. Or we'd head to the Rusty Nail across from Jean Lavina's Isle de France. That's all changed now. The Knees is now a shopping plaza. The Nail was moved to a different location lower on the Mountain Road. The Isle de France is now the home of Piecasso. And Jean Lavina, the little French chef/ owner of the former Isle de France, has passed away. C'est la vie.

Getting back to the Front Four trails on Mansfield and my encounter with Goat, on the occasion of the big slalom ski race, with much curiosity, I took the lift up to the top and made my way down Goat, where the races were happening. The trail was slick and steep. I bottom-slid down the upper part of Goat to the races and then bottom-slid the rest of the way down after the race, though there are many locals and tourists who ski all four of these trails with style and grace.

Susie Chaffee's a Vermonter, accustomed to the steep terrain of the trails, but Billy was from the West, brought up on long, powdery trails in wide-open spaces. It may have challenged him in the slalom races but had no effect on his aerial performances. On Little Spruce, Billy did his stunts, ascending high into the cold, brisk air from the jump, doing a flip (maybe even two) and landing on his skis, cowboy hat still in place.

Vermont is rated fifth globally and first in the United States as a "destination stewardship," noted a *National Geographic* study that measures environmental quality, social and cultural integrity, quality of management of tourism, aesthetic appeal of the area and historical preservation, and it possesses the most hopeful outlook for the future.

Jeanette after her day of gardening at age eighty-four at Mount Sterling Farm. "The End."

ABOUT THE AUTHOR

Evelyn Grace Geer lives in Sterling Valley in Morristown, Vermont. She was born in Worcester, Massachusetts, and grew up in the country in the town of Sterling, Massachusetts, where she found her passion for writing as a young girl. "Writing became my voice where I began to express my inner world and my love of nature and spirit."

She moved into a cabin in the woods up in Sterling Valley in Stowe, Vermont, at the age of nineteen. Then she traveled extensively throughout the United States, Canada, Mexico and the Netherlands Antilles. She spent three years in La Jolla, California, where she worked as a makeup artist and consultant for Estée Lauder. She also worked as a fashion coordinator and fashion advisor for Ports International on Girard Avenue in La Jolla, but Vermont had her heart, and she soon returned to the Green Mountain State.

She went on to earn a bachelor of fine arts degree in English with a concentration in creative writing at Johnson State College in Johnson, Vermont. She was the managing editor of the college newspaper while she was a student there and wrote a chapbook of poetry, "Blossoms to Bones," as her thesis in creative writing.

She married David Earl, the editor of the USGA's official magazine, *The Golf Journal*, and traveled throughout the United States, Europe and the French West Indies with David and their son, Sean Patrick Earl.

Evelyn was an art columnist for the *Stowe Reporter*. At the suggestion of her editor, Dan Bellow, the son of the late writer Saul Bellow, her column was called "What Is Art?" She has written for *Vermont Golf* magazine. Her piece "Collecting Vermont Golfiana" appeared as a feature in an issue, as did profile pieces on Joe Kirkwood and Vermont golfer Holly Reynolds, among others. Her writing has also been published in *The Stowe Guide* magazine and the *Burlington Free Press*. Evelyn wrote a weekly two-page feature about life in Jericho and Underhill, Vermont, that appeared in the weekly Morrisville newspaper, the *News and Citizen*.

She also finds an avenue for her artistic expression as a photographer and as a painter of pictures. She likes working on canvas with oil paint, as well as with watercolor. Upon David's death, she studied oil painting with Ken Leslie at Johnson State and then with the award-winning watercolorist Lisa Forster Beach of Stowe, Vermont. She traveled with Lisa and a group of other female artists to Italy, where she painted in Rome, Tuscany, Portofino and the Italian lake region of Bellagio. Evelyn has shown her work in galleries in New England, and her paintings are in private collections in homes in Vermont. She is married to Jake Geer, noted painter of the Vermont landscape. This is her first published book of nonfiction.

Visit us at
www.historypress.net